HIDDEN HISTORY OF THE
MID-HUDSON
VALLEY

Carney Rhinevault

HIDDEN HISTORY OF THE MID-HUDSON VALLEY

STORIES FROM THE ALBANY POST ROAD

CARNEY RHINEVAULT *and* TATIANA RHINEVAULT

Charleston · London

THE
History
PRESS

Published by The History Press
Charleston, SC 29403
www.historypress.net

Cover image: Washington Irving stops at the Warren Tavern in Cold Spring, watercolor by
Tatiana Rhinevault.
Illustrations by Tatiana Rhinevault.

First published 2011

Manufactured in the United States

ISBN 978.1.60949.414.8

Library of Congress Cataloging-in-Publication Data
Rhinevault, Carney.
Hidden history of the mid-Hudson Valley : stories from the Albany Post Road / Carney
Rhinevault and Tatiana Rhinevault.
p. cm.
Includes bibliographical references.
ISBN 978-1-60949-414-8
1. Hudson River Valley (N.Y. and N.J.)--History, Local--Anecdotes. 2. Hudson River Valley
(N.Y. and N.J.)--Biography--Anecdotes. I. Rhinevault, Tatiana. II. Title.
F127.H8R48 2011
974.7'3--dc23
2011031267

Dedicated to our son, Peter Vermeer Rhinevault.

Contents

Contents

His High Mightiness Is
Wearing a Dress!

There is a legend that one night in the early 1700s, perhaps when there was a full moon, a drunken prostitute was spotted by a guard at the fort on the tip of Manhattan Island while she staggered along the dirt ramparts. It turned out to be no prostitute but was instead His High Mightiness Governor Edward Hyde (1661–1723), Lord Cornbury, fluffing around in a dress. He was immediately "dragged out of sight by his own shamefaced soldiers."[1] Alarm and confusion spread quickly

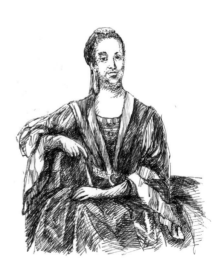

Lord Cornbury, wearing his
favorite dress.

from the fort's guardhouse through the harbor docks and village streets, through the taverns and grog shops, through the darkened clapboard houses of tradesmen, through the brick and stone homes of old Dutch merchants and through the earth and dugout homes of poorer folk north of the stockade wall. House slaves quickly awakened from their beds on the floor to help the merchant ladies get dressed. What was going on? Was the governor drunk, or was an enemy attacking? Possibly the governor had lost his nerve and his mind. For today's confused reader, a little background information is in order.

THE FORT

The fort sat at the southerly tip of Manhattan (just north of today's Battery Park). Its construction was begun by the Dutch West India Company in 1612 and was completed in 1635. The Albany Post Road began at the fort and ended 156 miles to the north, at Albany. The fort was about the size of a modern football field and was the economic, political, military, cultural and religious center of the colony of Nieuw Nederlandts. The fort, originally

Wheat was milled by wind power.

named Fort Amsterdam, was renamed Fort James when the British took over the colony in 1664. It was then renamed Fort William, then Fort Anne and finally Fort George (obviously named after whoever was king or queen of England at the time).[2] Its walls were made of dirt, and the four corner bastions were made of stone. Inside the fort were barracks for a 150-man military garrison, a guardhouse, the governor's house, storehouses, an armory, a powder magazine and a stone church.

The fort survived until the summer of 1789 after the American Revolution, when it was razed. The dirt walls were used for landfill in the Hudson shoreline, and the stone was used, in part, to build the "Government House," intended for use by the three branches of the new federal government. However, the Government House stood unused for that purpose when our nation's government moved back to Philadelphia in 1790 to await construction of the new capital at Washington, D.C. Instead, Governors George Clinton and John Jay used it as a residence, and it was used as a customhouse from 1799 until it burned down in 1815.

THE POST ROAD

The early history of the colony of Nieuw Nederlandts is really the history of two cities: Nieuw Amsterdam on Manhattan Island and Fort Nassau (Albany) farther north up the Hudson River (or North River, as it was called back then). Communication between the two cities (and the great estates, patroonships and tenant farms between them) was very sporadic and slow. A sailing vessel would take ten to twenty days to struggle from Manhattan to Albany. The Hudson River would freeze over in the winter, and travel by sail would come to a halt. No real roads existed on land, either. The Dutch colonists solved their communication problem in a most pragmatic way: letters would be collected at Fort Amsterdam, and then once a week or once a month a trusted Indian would run a pouch either up the river on ice or up the east side of the river on a footpath. Sometimes, but rarely, a healthy Dutchman would offer to be the mail carrier. We can "fancy the lonesome post journeying alone up the solemn river…skating swiftly along, as a good son of a Hollander should, and longing every inch of the way for spring and the 'breaking-up' of the river… [or] sometimes climbing the icy Indian paths."[3]

In the summer, a Lenape Indian, wearing the mail pouch, a cloth over his private parts, leather moccasins and not much more, would take off on a trot and head north through the small Dutch village. Soon he would be on the Mohican Trail and pass two Indian villages on Manhattan Island: Werpoes (near today's city hall) and an unnamed village at the caves of today's Inwood Park near 204[4] Street.[4] The trail was generally two feet wide and, in places, was beaten down to a depth of one foot. The trail wound around steep spots, swampy spots and other difficult areas. If the creek was high at the fording place at Spuyten Duyvil Creek, there would be canoes for his use. North of the creek, he would pass "fields with scattered wigwams and gardens on both sides of the dirt path."[5] Farther north, he would pass any one of a number of Indian villages: Napekamak (now Yonkers), a Weckweesgeek village at modern Dobbs Ferry, an Alipconck village at today's Tarrytown, a Hokohongus village at Sintsink ("Stony Place" or today's Ossining), the Senasqua village at today's Teller Point, the Meahagh village in the modern town of Cortlandt and on and on past perhaps ninety villages before reaching Fort Orange.

A 1702 Dutch home in New York City.

A hearty Indian could make seventy miles in a day, so an overnight would be made at Poughkeepsie, halfway between the forts. There is a legend that

> *a small kill sprang in an open woodland where the cattail weeds waved in the wind above the rockpool. Crossing the path the killetje rippled down a little glade, and fell into the Hudson…Massany…the name of the stream that still splashes through the* [Poughkeepsie] *Rural Cemetery on its river bound course…Here, lay a station along the Indian runners' path to the Manhattans, a "rest place," where mats woven from the reeds* [upuhki] *hung upon bent saplings to form a lodge-covering, or serve as mattress on the damp ground. Doubtless from a tree branch above the water-place* [ipis-ing] *dangled a haunch of venison to refresh the weary messenger.*[6]

After the British took over the colony in 1664 and during the time of Lord Cornbury, a white English post rider would be sent out on horseback and "would sometimes carry a woman passenger on a pillion behind him."[7] In 1753, the Mohican Trail was widened by Lord Lowden during the French and Indian War to accommodate wagons. About that time, it became known as the Post Road, later Broadway (or Broad Way) and still later U.S. Route 9 and State Route 9H.[8]

THE TRANSVESTITE (OR WHATEVER THEY WERE CALLED IN 1702)

Now back to the legend. On May 3, 1702, the leading citizens of New York City waited on the ramparts of Fort William as they watched the British warship *Jersey*[9] enter the harbor. On board the ship was their new governor, Edward Hyde, Viscount Cornbury, son of the Earl of Clarendon. Because most of the governors preceding Hyde had been pretty bad, many of the people waiting weren't expecting much. What they got was probably lower than their lowest expectations.

Edward Hyde, apparently, had been appointed governor solely on the fact that he was a first cousin of Queen Anne, after whom he soon renamed Fort William. He had served in Parliament for sixteen years, but

that also was most likely due to his family connections. Cornbury had accepted his assignment across the ocean probably to escape his creditors in England, and perhaps also he heard that there were opportunities in America to make a lot of money.

Supposedly, one of the first things he did upon arriving in New York was to drop a lot of hints that he needed money. Obligingly, several politically minded people, who hoped to receive favors from the new governor, pooled their money (an amazing total of £2,000) and presented it to Cornbury at a fancy banquet at Fort William. The givers waited impatiently for the feast to end and for Cornbury's speech thanking them for the money. Instead, he shocked the assemblage with a ridiculous monologue about the beauty of his wife's ears.[10] He even invited the men present to march past his wife, feel her ears and admire the soft texture.

According to the legend, things got worse after that. Cornbury not only had an ear fetish, but (according to various respected historians) he was also a drunk, an eccentric, a religious bigot, a pervert, a thief, a fraud, a cheat, a liar and even a cross-dresser. For the next six and a half years, Lord Cornbury's list of transgressions grew long indeed. Once, while inebriated, he allegedly rode his horse into the King's Arms Inn on the Post Road and ordered grog for himself and water for the horse. Typically, after downing the drink, he rode out without paying.

Because he was the queen's representative in the New World, and because the queen was of the Anglican religion, Cornbury saw it as his duty to bully any Dutch Reformed or American Presbyterian minister who happened to cross his path. When a Dutch Reformed pulpit would become vacant, Cornbury would invariably fill the seat with an Anglican priest, enraging the congregation. After a few years in America, he became bolder and bolder in his religious intimidation. He even went so far as to arrest a Presbyterian minister, Francis Makemie, for preaching in the city without a license.[11] No matter that Anglicans didn't need a license. Makemie spent three months in jail for his "crime." Another Presbyterian minister, William Hubbard, was evicted from his church and banned from ever preaching again.

Both Cornbury and his wife (with the beautiful ears) were purported thieves.[12] They had the attitude that if they liked something, it was theirs. If a citizen heard the governor's carriage rattle up to his front door, he and

his family would hurry to hide anything of value. "His High Mightiness" (as governors were called at the time) also allegedly perpetrated an enormous fraud upon the citizenry. Early in his tenure as governor, he told his subjects that he had information that a French fleet was about to attack the city. The frightened citizens coughed up £1,500 to build cannon batteries at the harbor narrows, but somehow the batteries were never built (and the French never attacked). Instead the £1,500 pounds was used to build a mansion for the governor.[13]

Supposedly, Edward Hyde would accept a bribe from anybody; although in those days, it wasn't called a bribe—it was a favor. On a cruise up the Hudson River to inspect his domain, he handed out huge land grants to anybody who would slip him some cash.[14] One recipient, Peter Fauconier, Cornbury's secretary, even named his grant on the east side of the Hudson River Hyde Park in honor of his boss (located on the Post Road, it was later the home of President Franklin Delano Roosevelt). "Cornbury made an elaborate event out of his first trip up the Hudson to Albany. He had his sloop decorated in gaudy colors and crew dressed in fancy new uniforms almost as brilliant as his own peacock apparel."[15]

The most interesting part of the dubious legend tells of Hyde's cross-dressing. It was the escapade for which he will forever be remembered. After the story of the governor parading around the fort in a dress got out, the governor allegedly made no attempt to hide "His High Weirdness" (the author's words) and would make night attacks from behind trees. Pouncing on men on several different occasions and screaming with laughter, he would box and pull his victims' ears (again, the ear fetish).[16]

In 1708, a Whig victory in England's Parliament created a distressing situation for Hyde in America. He had lost his supporters in the government, and Queen Anne was forced to remove him from office. His enemies, least of whom were his many creditors, had him tossed into debtors' prison for several weeks until word reached the colonies that Hyde's father had died and that Hyde was now the new Earl of Clarendon. Because he was then immune from prosecution, his unlucky creditors were left holding an empty bag. In December 1708, he departed for England (without his wife, who had died in 1706), where he apparently led a more normal and peaceful life. As of today, other New York governors have been unable to top his legend and legacy of

audacity, boldness, criminal intent and lack of scruples. All of the charges against him are historically questionable, "but belief in his transvestism was buttressed for years by a portrait of Cornbury in women's clothing that hung in the New-York Historical Society."[17] It has been determined that the unsigned portrait was not assumed to be that of Cornbury until 1867, 165 years after his arrival in New York.

The site of the old fort has changed dramatically. After the customhouse fire in 1815, the north side of the site

> *was given over to private residences, a row of fashion for many years until society began the migration uptown. Until the end of the nineteenth century the old red brick row was occupied by the New York offices of a number of the most important transatlantic steamship companies, among them the Cunard, the White Star, the French Line, and the North German Lloyd.*
>
> *The present Custom House [2007], from designs by Cass Gilbert, was erected in 1902–1907 at a cost of $7,000,000. The area of its seven floors is 300,000 square feet. The building is of granite in the style of the modern French Renaissance.*[18]

Prendergast's Army and the Wild Ride on the Post Road that Saved Its Leader

I n 1766, just at the time when the anti-rent riots were really heating up in Columbia County (more on that later), trouble was brewing farther south in the eastern sections of Dutchess County near the tiny hamlet of Pawling. Surrounding the hamlet were thousands of acres owned by Frederick Philipse III[19] of Yonkers, which were rented out to scores of tenant farmers. One of those hardworking farmers was an Irish immigrant with a strong will and strong back named William Prendergast (1727–1811). Ten years earlier, Prendergast had married an eighteen-year-old Quaker girl, Mehitabel Wing (1738–1812), who had a will even stronger than his own.

Like every one of his neighbor tenant farmers, William sure didn't like paying rent on land that he had cleared with his own hands and on a house that he had built with the same hands. Philipse owned the land, solely because of the accident of his birth into a rich family, and had never worked a day in his life. In fact, Frederick Philipse III was so fat from inactivity that his obese frame could only squeeze into a carriage built for two. William and Mehitabel had two sons, and with another on the way, William felt trapped in a bad situation with no escape from the Royalist Philipse family. He knew that he would never own the fields that he worked, and neither would his sons.

Tenant Farmers March

William's Irish blood finally forced him into action that might free him from his trap. Prendergast was a natural leader and was soon able to muster an army of a thousand farmers who, to the last man, were willing to fight. Their first act of violence was perpetrated against a justice of the peace named Peters, who had served as Philipse's paid legal enforcer by tossing farmers off their farms and into jail. Two men had been taken all the way to New York City to get them away from friendly crowds in Dutchess County. Prendergast declared, "If any officer attempts to take me till this dispute with the landlords is settled, I'll make daylight shine through him!"[20] Marching south along the Post Road through the Hudson Highlands and Westchester County, Prendergast's group of desperate men repossessed farms that had been taken from tenants by the manor lords. As they approached Manhattan Island at King's Bridge, word spread among the frightened city dwellers that an army of vengeance would swoop down upon them at any moment. General Thomas Gage ordered that His Britannic Majesty's grenadiers be assembled at Fort George at the southern end of the Post Road, fifteen miles south of the Prendergast Army encampment. Gage knew full well that his two hundred soldiers were no match for the thousand or more men in Prendergast's Army.

The farmers' grievances were not so much against the English government as they were against the detested landlords who stole their money, farms and labor. So instead of invading the city, six emissaries were sent by Prendergast to the fort to make known to General Gage and the governor their demands against the landlords. While at the fort, the six farmers were shown by Governor Henry Moore (1713–1769) an impressive display of the grenadiers on the parade grounds before they departed. After the emissaries returned to King's Bridge and told exaggerated stories of the British strength, it wasn't long before Prendergast's Army had lost the will to fight a battle (which they could have won nine years before the Battle of Lexington and Concord).

THE CITY IS SAVED

Prendergast turned his attention to Poughkeepsie, where he and his army of one thousand rode down the Post Road, past Henry Livingston's manor house,[21] to the jail in the center of the village. There they freed a farmer named John Way and forced manor lord Petrus Ten Broeck to make a humiliating withdrawal of his claims against Way. Other farmers were also freed and restored to their homes and farms.

Governor Moore had had enough and decided to rid his colony of Prendergast and the other pesky rebels. It just so happened that a force of three hundred grenadiers was due to sail from Albany to New York City, so they were ordered to land at Poughkeepsie instead. The Prendergast Army of farmers had pretty much all gone home to tend to crops, so their leader knew that he was in real trouble.

LAST STAND AT PAWLING

Prendergast and about fifty of his men decided to make a last stand in home territory near Pawling at the Quaker Hill Meetinghouse. Upon their retreat, they killed two of the grenadiers, infuriating the English soldiers. It now became a fight to the death, but before there were any more killings, Prendergast surrendered. He was marched straight to the Poughkeepsie docks and taken to New York City on a Hudson River sloop. About three months after his army had panicked the city, he was now a prisoner in the Provost at the commons on the Post Road in the city. While he languished there for a month,[22] preparations were made in Poughkeepsie for his trial on the charge of treason.

Prendergast probably could have been found innocent if the jury had actually been made up of his peers—tenant farmers—but that didn't happen. The twelve men on the jury were freeholders and manor lords, the prosecutor was a landlord and the chief judge (Daniel Horsmanden) was the same anti-farmer, anti-slave bigot who had sentenced so many blacks to death in 1741 during the slave conspiracy. In addition, Prendergast could not find an attorney to represent him because all of the attorneys' best paying clients were wealthy landowners.

Prendergast was forced to defend himself with extraordinary help from his extraordinary wife, Mehitabel: "During the whole long Trial, she was solicitously attentive to every particular; and without the least impertinence, or Indecorum of Behavior, sedately anxious for her husband, as the Evidence open'd against him she never failed to make every Remark that might tend to extenuate the Nature of the Offence, and put his Conduct in the most favorable Point of View."[23] The evidence against Prendergast was overwhelming and his case was almost indefensible, but William's wife was working magic in the courtroom. Her soft voice and cool logic was a counterbalance to the bellowing of the prosecutor. The hours wore on, and with no empty rooms in Poughkeepsie for the judge, jury and courtroom audience to spend the night, there would be no recesses or adjournments. During the marathon twenty-four-hour trial, Mehitabel was so effective that the prosecutor moved to have her removed "lest she might too much influence the Jury by her very Looks." Horsmanden ruled against the motion, stating that if he removed her that the court "might as well move that the Prisoner himself should be cover'd with a Veil, lest the Distress painted in his Countenance should too powerfully excite Compassion."[24]

GUILTY

The verdict was guilty. Mehitabel's spell had everybody in the courtroom in tears,[25] but the evidence was too strong. The sorrowful judge had no alternative but to declare upon William the usual gruesome death sentence for traitors. "The prisoner is to be led back to the Place whence he came, and from thence shall be drawn on a Hurdle to the Place of Execution, and then shall be hanged from the Neck, and then shall be cut down alive, and his Entrails and Privy members shall be burned in his Sight, and his Head shall be cut off, and his Body shall be divided into four parts, and shall be disposed of at the King's Pleasure [pleasure!?]."[26] William Prendergast's reaction to these gruesome words was a simple, "May God have mercy on my soul."[27]

After recovering from the shock of the sentence, Mehitabel kissed her husband, whispered something in his ear, hurried out the front door of

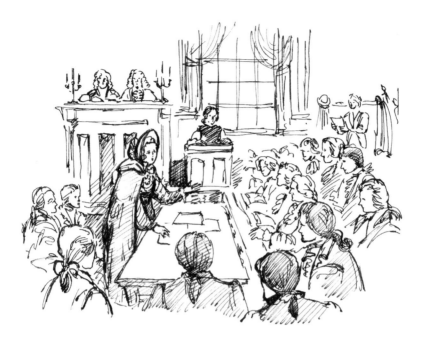

Mehitabel Wing defends her husband at Poughkeepsie trial.

the courthouse to a waiting horse and galloped south on the Post Road. She had expected the guilty verdict, and her plan was to head for New York City to plead with the governor to spare her husband's life. She had planned for everything down to the smallest detail. From her brother she had borrowed a strong and well-rested horse, and from her sister she had borrowed a pretty blue dress to impress the governor.[28] After not sleeping for at least twenty-four hours, she began the eighty-mile trek with courage that few men possessed.

Wild Ride on the Post Road

Past the rickety plank bridge over the Wappingers Falls and through the cleft in the mountains south of Fishkill, Mehitabel rode alone. The journey must have been exceedingly frightful for a lone female rider with neither an escort nor a firearm for protection against the bandits and murders who roamed the twenty miles of desolate Post Road between

Fishkill and Peekskill. Low-hanging branches of locust and hawthorn trees would have grabbed at her clothing as she hurried along the treacherously steep banks of the Croton River. One can wonder if she spent more than a few minutes at inns in Fishkill, Peekskill, Tarrytown or the hamlet of Sing Sing to refresh herself and exchange horses. If her pacifist Quaker heart held any animosity toward the Philipse family, she would have had to ignore her feelings as she passed the grand Philipse mansions in North Tarrytown and Yonkers. She perhaps felt some relief as she trotted her horse across King's Bridge onto Manhattan Island, but there were still fourteen miles to go to reach the fort and the governor's house. Along Harlem Heights and Harlem Plains, wading through the East River estuary and up the steep climb through McGown's Pass, she urged her weary horse. Past the Bowery farms and orchards and down the final stretch of built-up settlement along the Broad Way she went.

Mehitabel's frantic haste to see the governor was for good reason. She was not only attractive and strong-willed, but she had a goodly amount of common sense, too. As she had left the courtroom in Poughkeepsie, she knew that her neighbors and friends wouldn't wait long to try to break her husband out of jail. If that happened, all of her efforts would be for naught and her husband would become a fugitive.

After changing into her sister's "pretty blue dress," her interview with Governor Sir Henry Moore went well. Her pleadings and demure attractiveness worked better on the governor than on the jury back in Poughkeepsie. Supposedly, Sir Henry was moved to tears and assured Mehitabel that no harm would come to her husband. Together, Sir Henry and his relieved petitioner wrote a letter to the king in London asking for a full pardon for William Prendergast.

Having accomplished part of her mission, Mehitabel knew that she had to make a quick retreat to Poughkeepsie before her neighbors ruined her efforts. Back on the Post Road, she began another horse relay. She forded streams, climbed the Highlands north of Peekskill and traversed down again through the steep Clove Valley into Fishkill. Luck was with her because she reached the jail at Poughkeepsie just in time. Her neighbors had surrounded the jail and other government buildings and would have freed her husband and made him a fugitive had she not brought the governor's reprieve.

William Prendergast Is Saved

Six months later, the pardon from the king of England arrived in Poughkeepsie. Joyous tenant farmers escorted William and Mehitabel Prendergast back to their rented farm in Pawling.[29] All of the tenant risings had an effect on some of the manor lords, especially the Philipse family. Eight years after his imprisonment, and one year before the Revolutionary War began, William Prendergast was given a deed to his 249-acre farm in Pawling,[30] for which he had fought and risked so much. The Philipse family chose the wrong side in the war, and ironically, it was they who lost everything, not Prendergast. After being reprieved by the king in 1766, Prendergast's neighbors respected his neutrality during the Revolutionary War.[31]

Revolutionary War Spies
on the Post Road

The British

Sir Henry Clinton and General Burgoyne

Before and during the critical Battle of Saratoga, British spies used the Post Road to carry messages between the British army of Sir Henry Clinton (1738–1795), which occupied the lower Hudson region, and the British army of General Burgoyne,[32] which had invaded New York from Canada. British ships on the Hudson River always created a stir, so the only route left to the British was the Post Road. The British were forced to send daring couriers directly through lands populated by the Continentals. Sometimes Clinton's messengers would arrange to meet Burgoyne's messengers at a halfway point on the Post Road instead of making the entire 150-mile journey one way. A common rendezvous was at Livingston manor, probably because there were so many Tories in the area. Often, before reaching the safe area of Livingston manor, however, the spies were caught, tried and hanged. One spy, named Huddlestone, was hanged on the hill behind the Stephen Hendriksen Tavern on Market Street (Post Road) in Poughkeepsie.[33] Sometimes thousands of people would flock to the settlement to witness the hangings and would almost overwhelm the small village.

Other spies who were caught included Samuel Geake, Major Hammell, Henry Williams, Francis Hogel, Daniel Taylor, Isaac Vanvleek

Sir Henry Clinton.

and William Showers. Some made it through rebel territory, however. According to minutes of the Committee for Detecting and Defeating Conspiracies, a "mulatto wench" passed through Poughkeepsie on her way to bring a message to Burgoyne.

SPY GADGETS

All types of spy tools were used by the couriers. Quills of large feathers (the type used for writing letters) were hollowed out and thin strips of message paper inserted. One ingenious spy placed a tiny message paper inside an oval silver ball about the size of a musket ball. The ball was small enough for the spy to swallow if he were caught—and also small enough for him to hide in his hair (at a time when men wore long hair in big, puffy curls). When captured, the spy Daniel Taylor did indeed swallow the silver bullet. His act of swallowing the bullet, however, was witnessed by his captors. A rebel doctor "immediately administered a strong emetic, which was designed to work from either end."[34] Taylor vomited the bullet but quickly popped it back in his mouth and swallowed

it again. General George Clinton, the American commander, then threatened to hang Taylor and cut it out of his stomach. Faced with that proposal, Taylor consented to another dose of emetic. Taylor was hanged one week later, anyway.[35]

All of the British spy activity on the Albany Post Road was for nothing. Burgoyne was defeated at the Battle of Saratoga, which became known as "the turning point of the American Revolution." When Burgoyne surrendered his entire army, it consisted of roughly 5,500 British and Hessian soldiers. They were at first taken to the Boston area by way of the Post Road at Kinderhook and Claverack.[36] Finding conditions at Boston too crowded, General Washington, after a year, decided to move the entire captive army to Virginia. Again the prisoner army marched along the Post Road, only this time at Fishkill.

"Circus Army"

The sight of more than five thousand captive British and Hessian soldiers probably stirred emotions all along the Post Road. Many people who were loyal to the king of England must have been heartsick. On the other hand, Burgoyne's surrender undoubtedly persuaded many more people to throw in their lot with the Continentals. There was very little fence sitting after Saratoga. One can only imagine what the march would have been like. Unhappy soldiers, while trying to maintain their dignity, walked by fours or fives down the narrow dirt Post Road through the little hamlets of Greenbush, Schodack, Kinderhook and Claverack. The professional British soldiers, in their scarlet uniforms and polished buttons and boots, must have presented quite a contrast when compared to their American guards, mostly young farm boys, some dressed in rags and barefoot. Burgoyne's army has been called the "circus army"[37] because there was an incredible variety of camp followers that were also captured. They included two hundred officer's wives, dozens of children, hundreds of servants and even a small amount of woodland pets that the Hessians had gathered along the way: raccoons, foxes, bears and deer. Carts and coaches carried the families and seriously wounded soldiers. Once, a soldier's wife gave birth to a child in one of the carts and put a momentary stop to the march.

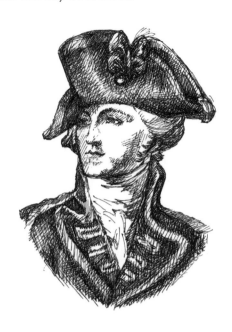

Gentleman Johnny Burgoyne.

People lined the Post Road to either heckle the prisoners or perhaps give some words of encouragement.[38] At Kinderhook, the Continental army provided four hundred barrels of flour and one hundred head of cattle to feed the prisoners, but local citizens also sold water from their wells and food from their homes to the prisoners. The British and Hessians actually paid for their first year of incarceration with gold guineas. As part of the surrender terms, they were allowed to keep their personal baggage, which included their money. The prisoners had to camp along the Post Road several times because of the slow pace of the march, an average of thirteen miles per day. The road between Albany and Kinderhook was heavily forested with stunted pines, but at each place the army stopped, the woods were stripped clean. South and east of Kinderhook, where the land was more settled, there were many complaints that the British "burned fences, destroyed fodder, [and] stole clothes and furniture."[39] Wherever there were barns available, the prisoners would pay to camp inside.

In October 1777, it must have seemed to the people along the Post Road that the war had ended, but it actually dragged on for another six years. On November 25, 1783, General George Washington led a

General Schuyler helping Baroness Reidesel (wife of Hessian leader) after the Saratoga surrender.

triumphal procession down the lower part of the Post Road into New York City shortly after the British had evacuated the city. Cannons roared and people cheered as they celebrated the final victory of their eight-year struggle.

Nathaniel Pendleton

A Little-Known Founding Father

Starting in the early 1900s, many sections of the Albany Post Road were straightened, leveled and paved with asphalt. Today's U.S. Route 9 is heavily traveled with automobiles and trucks, and it's a pretty safe bet that there is a car crash almost once a day somewhere on the road between New York City and Albany. In 1821, though, it was a different story. Traffic was light and slow, by either foot, horseback, horse carriage or horse wagon. So an accident or fatality was rare indeed.

On the night of October 20, 1821, one of America's lesser-known founding fathers met his fate on the Albany Post Road near milepost 84 in Hyde Park, Dutchess County. Nathaniel Pendleton (1756–1821), best known as second for Alexander Hamilton in his famous duel, lost control of his horse and became one of the first traffic fatalities on the Albany Post Road.

Pendleton's life story began auspiciously enough but was punctuated with more than the usual amount of mistakes and tragedies. He was born in 1756 into a high society Virginia family who were acquainted with the George Washington family. Little is known of his childhood, except that he became a notable musician and craftsman. In 1775, at the age of nineteen, he set off by foot from Virginia to Boston to join up with General Washington to fight the British. He became an officer in one short year.

Battle of Harlem Heights

On the evening of September 15, 1776, Lieutenant Pendleton and about nine thousand other American soldiers were encamped in thick woods at Harlem Heights on the Island of Manhattan. "To the west of the Americans was the Hudson River; to the south and slightly east stood the plains of Harlem; and directly to the south was a small valley called Hollow Way."[40] A rough forest road followed this valley beginning at its intersection with the Post Road at present-day 122nd Street and leading slightly northwest to the Hudson River. Farther south still were thousands of British and Hessian troops, who had invaded the island that very day.

The following morning, Lieutenant Colonel Thomas Knowlton and 120 of his elite rangers were sent across the Hollow Way by General Greene to ascertain the position of the enemy. Almost immediately, the Americans came under fire but made an honorable account of themselves. Other troops from both sides entered the battle, and when the smoke finally dissipated at sunset, it was clear that the Americans had won a small tactical victory but very large moral victory.

Battle of Fort Washington

Pendleton also fought in the disastrous Battle of Fort Washington two months later on the island, the biggest battle fought anywhere along the Albany Post Road. By November, the British had taken all of the island except a small area at the east end of today's George Washington Bridge. The area was undermanned by the Americans to the point that it was almost indefensible. The Continentals held the high ground, but military historians agree that the Americans needed at least 10,000 men to protect their positions, instead of the 2,800 that they did have. The other alternative would have been to concentrate their forces for a Bunker Hill type of defense. At any rate, the Americans' lines stretched across the island from the Fort Washington heights on the Hudson River to the Laurel Hill heights on the Harlem River. The Post Road bisected the battlefield in a valley, up the center of the island. On November 16, 1776, the British, under General Howe, began their attack with a

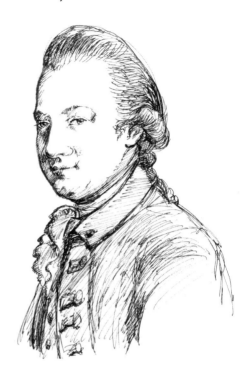

Lord Cornwallis.

bombardment from the frigate *Pearl* in the Hudson and from artillery east of the Harlem River.

The British had planned four separate assaults against the Americans. General Cornwallis would land troops at the north end of Laurel Hill, General Matthews and Colonel Sterling would land troops at the south end of Laurel Hill, General Knyphausen and his Hessian troops would assault Fort Washington from the north and General Percy would attack with the main British force directly up the Albany Post Road. The Continentals put up a stiff resistance, and the British attacks were poorly timed. It became apparent very early, however, that the British advantage of 8,000 men to 2,800 Americans would carry the day. The American lines began to collapse like air being slowly released from a balloon. After two hours of intense fighting, the Americans had all found shelter in the crowded main fort, which had been completely surrounded by the British and Hessians. Washington watched in horror from Fort Lee, across the Hudson River in New Jersey, as 221 officers and 2,631 soldiers surrendered.[41]

PAROLED AND MEETS HIS FUTURE WIFE

All of the Continental prisoners were kept in cruel conditions, such as derelict warehouses and dungeonlike cellars in New York City (what is now Lower Manhattan). Even the holds of British ships in the harbor were used as squalid prisons. The most infamous prison ship was the *Jersey*, on which a dozen or so Continental soldiers died of starvation or disease every day. Most of the officers (including Pendleton) were much luckier, however. They were allowed to sign a "parole" and were released into the civilian population. The officer had to promise not to take up arms against the captors.

After four years of idle parole in New York City, Pendleton's fortune turned from bad to good when he was offered lodging at the home of Dr. John Bard,[42] a prominent doctor in the city. Dr. Bard, who years later operated on and saved the life of President George Washington, had a pretty young daughter named Susan. Nathaniel fell in love with her, and she accepted his marriage proposal. During his engagement to Susan, he and several other officers were exchanged by the British for British officers who were held by the Americans. Released from the terms of his parole, his marriage was put on hold, while the freed officers went off to Philadelphia to report to General Washington.

BATTLE OF EUTAW SPRINGS

While at Philadelphia, many of the men were discharged from further military service by General Washington, but Pendleton actually chose to fight again for the Continental army. He was assigned as an aide-de-camp to General Nathanael Greene,[43] leader of the American forces in the South, during the final years of the war. The last battle fought by Greene's men on September 8, 1781, at Eutaw Springs (near Charleston, South Carolina) was a smashing moral victory for the Americans. The battle is noted in history as one of the toughest fights during the American Revolution. The combat was mostly hand to hand, with bayonets and heavy losses on both sides. The British suffered the worst, with about 900 men killed or captured out of a force of 2,300. The Americans lost 522

out of 2,300. When news of the victory was spread across the country, the American people took it as a sign that American militia could fight the British on equal ground and come out bloodied but the winner. America's "Poet of the Revolution," Philip Freneau, penned the following stanza:

> *At Eutaw Springs the valiant died,*
> *Their limbs with dirt are covered o'er—*
> *Weep on, ye springs, your tearful tide;*
> *How many heroes are no more!*[44]

Pendleton distinguished himself during the battle and was given a special citation for bravery by Congress. The citation was equivalent to the modern Congressional Medal of Honor, so it can be said that Nathaniel Pendleton was one of the United States' first Medal of Honor recipients.

MISSES SIGNING THE UNITED STATES CONSTITUTION

Nathaniel studied law in Georgia and began his civilian career as an attorney in Savannah. Pendleton "was a delegate to the convention of 1787, which framed the Constitution of the United States, though being absent on the last day of its sessions, he failed to sign the document."[45] By missing that one day, Pendleton is now only a footnote in America's history books and is somewhat of a mysterious character. His political career ended before it ever got started.

LOVE AFFAIR

It was in Georgia where his life began to unravel and seemed to move from one mistake to another. He had married his sweetheart, Susan Bard, but at the same time had fallen in love with Caty Littlefield Greene (1755–1814), wife of his former commander, General Nathanael Greene. The romance with Caty was characterized by fear and regrets on the part of Pendleton and flirtation and jealousy (of Susan) on the part of Caty.

General Nathanael Greene,
Washington's second in
command.

Caty Greene, about the time
of her affair with Nathaniel
Pendleton.

At the same time that she was dangling Pendleton on a hook, she was having more or less serious affairs with three other men. After Caty's husband died of a sunstroke in 1786,[46] the affairs with Pendleton (and others) heated up. On July 27, 1790, Caty wrote to Nathaniel, "It is now two o'clock and I have not been in bed yet—the strongest wish I have at this moment is that you were here in my room."[47] In an attempt to keep temptation away, Pendleton wrote to Caty in New York City, "Tho I can't help wishing to be in the same place with you always, yet I can't in my conscience persuade you to come back to this vile corrupt country."[48]

OWNS SLAVES IN SAVANNAH

The "corrupt country" that Pendleton referred to was the state of Georgia, and Pendleton himself was part of the corruption. No longer just an attorney, he was chief judge in Georgia and had attained enough wealth to settle his family in a fine mansion in Savannah, on Yamacraw Bluff, near the harbor.[49] His wealth included slaves, one of whom ran away. Pendleton placed an ad in the *Gazette of the State of Georgia* that read, "Run away...a negro fellow named Tom...He is a young fellow, talks plausibly, and lets his beard grow, which is short and thin. He has a wife or two in or near Savannah, where it is probable he lurks. Whoever secures him, so he is delivered to me, shall receive five guineas reward."[50]

YAZOO LAND SCANDAL

By 1795, Pendleton had become embroiled in one of the biggest land scandals in United States history. At the time, the state of Georgia's westerly boundary was the Mississippi River, and all of the land in what is now the states of Alabama and Mississippi was actually part of Georgia. The land (known as the Yazoo lands, named after the Yazoo River) was undeveloped and sold to speculators, mostly who lived in the northern states. Rich Yankees invested millions of dollars at two to four cents per acre to obtain the land, which they hoped to resell at a huge profit. It was a "get-rich-quick" scheme on an immense scale, but it soon backfired

when the Georgia legislature changed its mind, nullified all of the Yazoo contracts and wiped out the speculators with no compensation. Pendleton, as chief judge, should have stayed out of the Yazoo mess, but he had actually invested his reputation and all of his money and property in the deal. He was forced to escape with his family to his in-laws' house at the corner of Broad and Wall Streets in New York City in 1796. Pendleton's failure to sign the Constitution was the beginning of the end of his political career, and the Yazoo scandal was the end of the end.

Before the scandal had reached Washington's ears, our first president had "suggested Pendleton's name for Secretary of State, but the suggestion was opposed by Alexander Hamilton, who feared that he was 'somewhat tainted with the prejudices of Mr. Jefferson and Mr. Madison.'"[51] Washington wrote a very friendly and complementary letter to Pendleton on March 3, 1794, thanking Pendleton for his remarks about Washington's position in regards to "the belligerent powers of Europe." Washington's handwritten and signed letter is now in the possession of the New York Historical Society.

EARLY POLITICAL FIGHTS

Politics in the late 1700s and early 1800s made today's Republican-Democrat quarrels look like polite tea parties. Many people make the assumption that our founding fathers were ethical and honest folk who all had the good of the country at heart. The reality was far from this: Jefferson hated John Adams; John Adams slandered Alexander Hamilton by calling him a "bastard"; Hamilton accused Adams of "disgusting egotism" and "ungovernable indiscretion"; Aaron Burr hated Thomas Jefferson; Hamilton called Jefferson a "contemptible hypocrite"; Dewitt Clinton hated Aaron Burr; James Madison disliked Hamilton with a passion; James Monroe almost fought a duel with Alexander Hamilton; Burr referred to Monroe as "naturally dull and stupid"; Robert Livingston harbored resentment for Jefferson; and of course, Hamilton hated Burr and Burr hated Hamilton.

Only President George Washington received the respect and universal esteem of his contemporaries.

ALEXANDER HAMILTON–AARON BURR DUEL

The political upheaval became more and more intense until finally, in 1804, only an explosion of some kind would cool down the situation. The Hamilton-Burr[52] explosion had many fuses. Both thought the other wanted to be king of New York and New England; both thought that their political career had been ruined by the other; and both had founded banks that competed with the other's. Pendleton had become close friends with Hamilton and, for some days preceding the duel, had tried to cool the dispute by carrying notes and letters back and forth to Burr's friend, William P. Van Ness (1777–1826). All efforts failed, however, and Hamilton, with his second (Pendleton) met Burr and his second (Van Ness) on the ledge above the Hudson River at Weehawken, New Jersey, on July 11, 1804. The duel has been analyzed by historians for more than two hundred years, but it wasn't until 1976, during bicentennial activities, that gun experts had a chance to examine the actual dueling

Aaron Burr shoots Alexander Hamilton. Nathaniel Pendleton stands at left.

pistols. They were both found to have hair triggers that could have been set if a person knew where the latch was located. Several historians refer to a conversation about the latch between Pendleton and Hamilton just before the duel, indicating that they knew about the hair trigger. Because the duel was over in seconds and nobody will ever know for sure, it can be speculated that Pendleton may have unwittingly set the hair trigger that led to Hamilton's misfire.

Escapes to Hyde Park

For months and years following the duel, Burr and Van Ness were characterized as murderers in the press, and even Pendleton was vilified for not doing enough to stop the killing. Pendleton and Van Ness were even indicted (but not tried or convicted) "by a coroner's jury as accessories before the fact to murder."[53] During this period, he wrote to his nephew-in-law, William Bard, "I wish it were in my power to comply with your father's request of coming up to Hyde Park. Never did my spirits require to be tranquilized by quiet and repose more than the present."[54] So, for the second time in his life, Pendleton escaped an oppressing situation by moving his family away—this time up the Post Road to Hyde Park, New York, where Susan's family lived in 1807.

Placentia.

38

At Hyde Park, he built a large but plain house out of brick about a mile north of the hamlet on the Albany Post Road near milestone 89. Appropriately, he named his house and estate Placentia (place of peace).[55] According to Benson Lossing, Placentia stood "upon a gentle eminence, overlooking a pleasant park of many acres, and commanding an extensive prospect of a fertile farming country on both sides of the river."[56] Pendleton was well liked and respected by his neighbors and gave generously to the Saint James Episcopal Church,[57] which was located on the Albany Post Road near his home. The church had been built mostly with money contributed by his father-in-law, Dr. John Bard, and his brother-in-law, Dr. Samuel Bard.

Even though he had become part of northern society, he still owned slaves at his Hyde Park home:

> *Judge Nathaniel Pendleton had a young Negro, named Paul (Paul Ray), whom he had brought from the south. He was a waiter and house servant. The Judge undertook to flog him for some offense. It was toward the close of slave times (in New York State), and the Negroes, knowing that emancipation was not far off, would not stand flogging as they used to. Paul escaped from the Judge's hands, and ran down through the orchard to Mr. Braman's. The Judge ran after him to the top of the hill, and called out to "arrest that fellow," but no attention was paid to the demand. Paul was asked what the trouble was. He told his story, whatever it was, and said he would never be whipped again. He escaped down the Albany Post Road to Poughkeepsie, where the Judge had him taken up and put in jail. Paul was afterwards a cook or steward on some steamboat running out of New York City. The Pendletons had several slaves. Old Molly was one. Louisa was Susan Bard Pendleton's own maid.[58]*

Paul Ray was finally freed under the terms of Nathaniel Pendleton's will in 1821.

Pendleton and his wife, Susan, had five children.[59] Pendleton was a big fish in a small pond and was very soon elected a Hyde Park judge. His judgment concerning his own financial matters was still questionable, however, as he continually tried to collect on old

(apparently uncollectable) debts. He even tried to sue his old girlfriend, Caty Littlefield Greene, for $10,000 that he felt that she owed to him. In 1821, it was another unpaid debt that finally caused his death.

FATAL ACCIDENT ON THE POST ROAD

Edward Braman, in an 1875 unpublished book, related the final story:

Judge Nathaniel Pendleton met his death in this way.—Elijah Baker, who lived near the present Delamater's Mills, owed him some money, and evaded payment. It is said that Baker, one night, or early one morning, took some hay secretly to ship from Poughkeepsie, instead of Hyde Park. The Judge heard of it, and started in his gig, or sulky, for Poughkeepsie, down the Albany Post Road, to get out an attachment on the hay. On the way down he was thrown out and killed. Some men who were working in a field on the present Stuyvesant place, first saw the runaway, but it is not known what started the horse, or where he began to run. The Judge was thrown, or jumped out, on the east side of the road, about the south end of the picket fence that runs in front of the house where Russell Livingston lately lived. A family named Osborn then lived there. Mrs. Osborn ran out and lifted up his head. She had a mattress brought out, and he was afterwards taken into her house on it. She could not see that he breathed at all, and it is probable he was killed instantly. The Judge had one glove off, and it is supposed he had taken it off to look at his watch. He drove with very short reins, and it is supposed that in pulling off or attempting to draw on his glove, he dropped the reins out of reach, and the horse, finding himself unchecked, ran away. It is thought that the Judge, finding himself nearing the top of Gay's Hill, jumped from the sulky. As he passed the men in the field, he was seen to wave his hat and heard to call to them, both probably serving to frighten the horse still further. The Pendleton family presented Mrs. Osborn with a silver tea-pot (or tea set), in acknowledgment of her kindness.

Mrs. Susan Pendleton was dead, but her sister, Mrs. Ann Pierce, lived with the Judge's family. When the news of his death was brought home, Mrs. Pierce was almost crazed for a time, running out to the brow

of the hill towards the house of Cyrus Braman, shrieking and calling to Mrs. Braman. The latter went home with her and tried to soothe her. At first Mrs. Pierce wanted to start off on foot, towards Poughkeepsie, to find the Judge. This occurrence made a profound impression in the quiet neighborhood of Hyde Park, and beyond its limits. The Albany Post Road, south of the Osborn house was altered, some years after, to avoid the steep declivity of Gay's Hill.[60]

Even after his death, Pendleton was first at something else. The Saint James Church in Hyde Park (like most churches of that era) reserved a cemetery behind the church building, and Pendleton was one of the first to be buried in the center area next to Drs. John and Samuel Bard.

Citizen Genet of
East Greenbush

Just before the Post Road reaches Albany, it passes through the town of East Greenbush. The "favorite son" of the town, certainly the most famous person to ever live within the town's borders, was not a "native son." He was Edmond Charles Genet, diplomat from France during President George Washington's administration.

Genet led a very raucous and controversial public life for five months after he first arrived in America and then settled down to a much quieter retirement while living in East Greenbush. "This period [while living in East Greenbush], in marked contrast to the fiercer struggles of his political life, was passed in peaceful retirement, and in courting the favor of the muses."[61] But even the story of his private life was interesting and needs to be told.

MIDDLE-CLASS CHILDHOOD

He was born at Versailles, France, January 8, 1763, the son of Edme Jacques Genet, a translator and interpreter for the French royal government.[62] While still in his teens, Edmond became fluent in Swedish, Latin, Italian and English. His parents and, more importantly, the French queen recognized his potential and sent him

on a grand tour of Germany and Austria to sharpen his skills. In 1781, after his father's death, Edmond began work for the French Bureau of Interpretation and more or less followed in his father's footsteps. Rising in the ranks of his department, in 1788 he was posted to St. Petersburg, Russia, as secretary of the legation. Apparently repudiating the privileges of his birth, he supported the cause of revolution in France and, as a consequence, was kicked out of Russia in 1792 by the royalist government.

DIPLOMATIC MISSION

After joining the Girondist faction in the French Revolution, he was sent to America on a mission to cement relations with the new United States government and convince the Americans to join with France in its war with England. Some of the more moderate leaders in France considered sending King Louis XVI with Genet, but the king's appointment with the guillotine on January 21, 1793, negated that possibility:

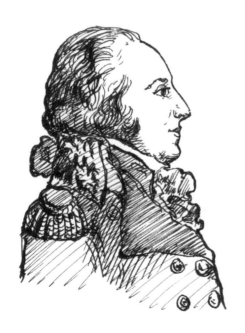

Edmond Genet.

Genet predicted America would receive the exiled king with open arms. Brissot and Lebrum asked Genet to undertake escorting the royal family to the United States. But spies reported the scheme to the commune and even as Genet was named ambassador to the United States so that he could carry out the plan to exile, the revolutionary court returned a death sentence for Louis.

News of this turn in affairs reached Genet as he waited at the dock (at Brest) ready to board ship. "Our plans have been discovered," the message read. "All hope is lost. Fly for your life."

Having gained the open sea, the presence of Genet on board caused a mutiny among the men, who swore he had secreted the king and the dauphin aboard. When, after diligent search, they could not be found, the voyage to America proceeded.[63]

Genet's arrival in Philadelphia (America's capital at the time) was further delayed by storms at sea, which blew his warship, the *Embuscade*, far to the south at Charleston, South Carolina, where it landed on April 9, 1793. If Genet was at all superstitious, he should have considered the ill winds as a bad omen for his diplomatic mission.

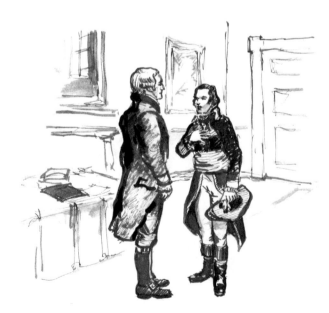

Citizen Genet meets President Washington.

Notice of the French king's beheading had reached America in March 1793, prior to Genet's arrival. As the shocking news spread, the majority of Americans began to feel that there was a basic difference between the American Revolution and the French Revolution. The average American Patriot who had fought for independence from an oppressive empire felt no blood lust against the English or their king. On the other hand, the French saw their revolution as an international struggle against all nobility and were actually championing an early form of communism. The news of the French king's execution opened a lot of eyes in America.

However, the newly arrived Genet was the face of the French people, who had helped the Americans win their independence ten years earlier. In Charleston and all along the roads leading to Philadelphia, he was cheered as his carriage and militia escort passed. So much attention and so many feasts were given for him that it took him an entire month to reach Philadelphia. A diplomat with his credentials and experience should have made the trip in four days and presented his letters of introduction to President George Washington the very first thing.

INCURRING THE DISFAVOR OF PRESIDENT WASHINGTON

Instead, Genet was blinded by all the adulation, compliments and friendship and made a series of very undiplomatic mistakes. On his own initiative and against the wishes of President Washington, he paid to have four privateer ships—the *Republican, Anti-George, Sans-Culotte* and the *Citizen Genet*—in Charleston outfitted for raids against the British. Also, he attempted to raise an army of American forces under the command of the alcoholic George Rogers Clark to attack the Spaniards in Louisiana and Florida and the British in Canada. Luckily, the American policy of neutrality was not damaged by Genet, as it soon became apparent that the average American citizen's love of the French was not nearly as strong as his respect for his American president George Washington.

Washington wanted to give the United States a few years of peace in order to build ties with other countries in the sphere of international trade. It was a bad time (there would never be a good time) to have the

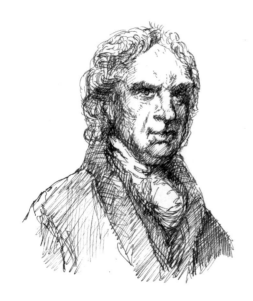

Governor and Vice President
George Clinton.

flamboyant Genet messing in political matters. In Washington's cabinet, opinions about Genet were divided. Hamilton wanted to kick him out of the country like the Russians had done, but Jefferson at first embraced Genet. While Genet waited for the president to decide what to do with him, he was treated with more lavish receptions and pageantry by the American factions who sided with him.

At one of these events, he was introduced to the pretty daughter of New York governor George Clinton, an ally of Thomas Jefferson's (and later Jefferson's vice president). Cornelia Tappen Clinton (1774–1810) would later, on November 6, 1794, become Genet's wife. They were married in the Government House[64] on the Post Road in New York City. When they first met, Cornelia was already infatuated with the French Revolution in principal and with Genet in particular. Genet, for his part, was charmed by her beauty and personality, and their married life at East Greenbush was mostly happy. The sizable dowry (£2,000) that Governor Clinton gave to Genet didn't hurt either. Before their marriage, however, they had to overcome one obstacle. "Hamiltonians had spread rumors that Genet already had a wife and two children in France…the governor [Clinton] refused to give his permission for the wedding until Genet's marital status was clarified…(proof arrived from France) and the rumors of a previous wife were refuted."[65]

Wherever Genet traveled, he seemed to stir up controversy. When word was received in New York City that he planned to visit, patriotic leaders of the Tammany Society decided to turn the annual Fourth of July celebration into "a day-long carnival of parades, fireworks, bell-ringing, singing, guzzling, stuffing, sermonizing, and speechifying" in honor of the French. Earlier, "in May, 1793 four hundred participants trained through the streets in red liberty caps,"[66] one of the symbols of the French Revolution. Just days before his arrival in New York, a major international incident occurred that threatened to drag America into the war.

A British frigate, the *Boston*, was docked at Manhattan at the same time as the French ship *Embuscade*, the same warship that had brought Genet to America. The crews of the two ships took to brawling at the bars on lower Broadway (the Post Road) and challenged each other to do battle with the warships. Setting sail on August 1, 1793, they pounded each other with broadsides off Sandy Hook. Witnessed by several boatloads of spectators, the *Embuscade* emerged from the smoke of the battle the clear winner. The *Boston* was still floating but was ripped to shreds. Genet felt that the pro-French enthusiasm generated by the skirmish would influence President Washington and Congress, but it only hardened their feelings against his troublemaking.

On August 12, 1793, there appeared in the *New York Diary* a notice signed by John Jay (chief justice of the United States Supreme Court) and Rufus King that read in part, "Mr. Genet, the French Minister, said that he would appeal to the people from certain decisions of the President."[67] Translated to colloquial language of the twenty-first century, this meant that Genet intended to "go over the head" of President Washington and encourage a coup against him by the American people. Genet's position in America had finally spun completely out of his control in the five short months since his arrival in Charleston. President Washington, at this point, asked the French government to recall Genet, and Genet made his fateful decision to ask the United States for political asylum in America. It was assumed by Genet that if he did return to France, he would probably be executed by the Jacobin regime, which had replaced the previous revolutionary council. Genet thus became one of the first people granted asylum in the United States.

GENET RETIRES AT THE AGE OF THIRTY-ONE

In 1794, at the age of thirty-one, an age when most men were in mid-career, Genet was ending his. With Cornelia's substantial dowry and his own savings, Edmond was able to purchase a 325-acre farm on Long Island. Eight years later, he decided to move closer to Cornelia's family, in the Albany area.[68] He sold the Long Island property and bought from his father-in-law (at a very cheap price) a six-hundred-acre manor estate, which he called Prospect Hill, on Hayes Road, one mile west of the Post Road in East Greenbush. Prospect Hill was aptly named because it became the scene of much business and invention prospecting, almost all of which failed.

Genet's life was filled with adventure. Even the trip from Long Island to East Greenbush was not uneventful. "The sloop, which conveyed me and my family frequently was detained on the bars between Kinderhook and Albany and my arrival was procrastinated several days by those impediments."[69] His family, his servants and all his household goods were on that sloop. One can imagine the group cooking their meals pioneer-style over an open campfire on the sandbar islands while the crew from the sloop speared fish for fresh food.

LIFE AT PROSPECT HILL

After finally reaching their new home, the Genets settled into a modest and sturdy brick house, which they called the Honeymoon Cottage on the eastern edge of the Hudson River tidal flats. The house had two portholes on the north side, as it was built at a time when homes still had to do double-duty as forts in time of Indian attacks.

The farm itself was the only business venture that Genet could count on to support his lifestyle. "A scientific farmer, he added to his acreage (of the 600 acres, 300 were woodland and the other 300 were pasture and tillable soil) and sold surplus wheat, fruit, and vegetables in Albany, where he also banked his money. He was an early sheep-raiser and owned his own grist mill."[70] While in Albany, he was often sought out for his linguistic skills to make translations for government officials.

In a matter of a few years, Genet's workers had built a large two-story mansion with a cupola and widow's watch observation platform on the roof. The new French-style mansion was built high up on the hill east of the original cottage and had spectacular views of the church spires of Albany and a beautiful stretch of the Hudson River. It was set back from the road in a grove of trees, which had been sent to Genet as seeds or seedlings by friends in France. Inside were huge fireplaces in several rooms and a kitchen in the cellar, where black servants cooked meals for the always-large crowd of family and guests. This was to be the family home until sold by Genet's children long after his death. It burned to the ground in 1916.

Across the road from the manor house was a steep, treacherous ravine called the "Hell Hole" by Genet. Perhaps the name was meant to discourage his children from wandering close to the pit, which would swallow them into hell. Near to the Hell Hole were sulfur springs, later called "Little Yosemite," which added demonic odors to the view before the ravine reached the Hudson River.

Genet's retirement life was probably happy even though it was occupied with unfulfilled dreams. Several times, he entertained the

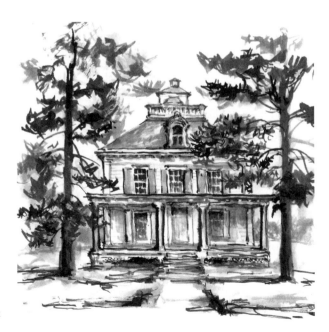

Citizen Genet's Prospect
Hill home.

idea of returning to France, but he never made it. After he became a naturalized citizen in 1804 (again, one of the first people to do this), he came close to visiting his family in Paris. However, he always held back because he felt that the people of France wrongfully blamed him for the failure of his diplomatic mission. He would wait forty years (the rest of his life) for vindication that never came.

Proposes Hudson Canal at the Foot of Prospect Hill

Genet's difficult experience moving his family from Long Island up the Hudson River planted an idea in his always-active mind. He theorized that the twelve miles of sandbars and shoals that were preventing oceangoing vessels from reaching Albany could be bypassed by building a canal through the tidal marshes in front of his house (the Honeymoon Cottage). Perhaps he also thought that he could gain some financial rewards for his family by selling some useless land to the state or a canal company. Maybe businesses would sprout along the canal on his land. He presented his idea to the state legislature, but only his in-laws, the Clintons, showed any enthusiasm.

Genet remained a dreamer and idealist his entire life and felt that he could accomplish anything if only he could convince other people that his ideas were sound. In the case of the canal, he couldn't find financial backers, but his theories about canal travel were proven successful when the Erie Canal opened several years later in 1825. Decades later, oceangoing ships do visit the Port of Albany, but they don't use Genet's never-built canal. Modern dredging of the Hudson River itself has made shipping to the port on the south side of Albany possible.

Genet also finally got to see his political views somewhat fulfilled when the United States declared war against England in the War of 1812. After 1814, he would visit the Greenbush Cantonment, located three miles to the northeast of his mansion down the Post Road, and make patriotic speeches to the four thousand or so soldiers stationed there to repel an anticipated invasion of New York by the British down the Champlain Valley from Canada. He probably mused on the irony

that the soldiers were poised to fight the enemy who he had spoken against nineteen years earlier. Genet's sons were too young at the time to serve as soldiers, and Genet was too old.

POLITICAL AGITATOR

Edmond Genet understood that as a person who had incurred the displeasure of George Washington, he could never run for public office and expect to win. He therefore assumed the role of political advisor and supporter for other men in the New York State Democrat-Republican Party. His father-in-law, George Clinton (1739–1812), ran for president in 1808, and Genet threw all of his energy into the losing campaign. A year earlier, his hotheaded activism had actually incited a nasty beating of one Albany politician and a revenge beating of the perpetrator by three of the victim's friends.

It all began on February 28, 1807, when, after the urging of Genet, Colonel Nicholas Staats of the State Assembly accused General Solomon Van Rensselaer of trying to bribe him to vote for certain political appointments in the Assembly. Just like the Alexander Hamilton–Aaron Burr duel three years earlier, one political party's newspaper would print one side of the argument, while the other party's newspaper printed the other side (as news and facts, not opinion). By April 12, accusations and counteraccusations were flying. Genet had done nothing and had seen nothing, but he had goaded Staats into making accusations against Van Rensselaer and was now in the middle of the fray. In the April 12, 1807 *Albany Register*, Genet said, "The case is now before the tribunal of the public, and I am satisfied to have done my duty as a citizen in exposing it there."

On April 21, the court case and newspaper battle turned violent. Elisha Jenkins,[71] an ally of Staats's, was ambushed by Van Rensselaer at the corner of State and Pearl Streets in Albany:

> *Van Rensselaer came up and struck Jenkins, which staggered him. He struck a second time, which knocked Jenkins down [and]…Jenkins had no notice of the attack.*

Medical testimony indicated that Jenkins' head had been cut open by Van Rensselaer's cane when the beating was administered.

Three hours later it was Van Rensselaer who became a victim of revenge. He too, was walking easterly on State Street and upon reaching Green Street was in turn caned, again from behind, by [John] Tayler[72] who was assisted by Dr. [Charles] Cooper[73] and [Francis] Bloodgood.[74] The only help afforded Van Rensselaer was by [Cornelius] Schermerhorn[75] who provided his friend with a new stick after his cane had been batted away.

Witnesses to that affray testified that Tayler had warned Van Rensselaer of his intent to assault him, that a duel of canes began and that Tayler, Bloodgood and Dr. Cooper managed to fell Van Rensselaer and that even after Tayler had been pulled from the melee by his daughter, the other two stood on Van Rensselaer's prostrate body and kicked him repeatedly after he had been knocked down by blows from the canes of his three antagonists.[76]

Although Jenkins's injuries were not serious, Van Rensselaer got the stuffing knocked out of him. One doctor who examined him thought (incorrectly) that he would never recover. Within a year, he did recover and was even appointed Albany's postmaster. Because no police officer had witnessed the melees, and because unbiased witnesses were difficult to find, no criminal charges were made. As a result of civil proceedings, however, "came judgments of $2,500 against Van Rensselaer in favor of Jenkins and of $300 against Tayler, $500 against Cooper and $3,700 against Bloodgood, all in favor of Van Rensselaer."[77]

It can be said that the first noteworthy act that Citizen Genet did after becoming naturalized was to instigate a bloody fracas among six prominent fellow citizens. After this mess, he stopped signing his real name to letters to the editor and began to call himself "Cassandra" or "An American Citizen." He continued to write essays about abolition of debtor's prison, the need for canal construction (the big public works projects of the time period) and opposition to proposed trade embargoes. He also injected his dislike of southern United States politicians into his writings. He continued to compose political material until about 1828, six years before his death.

A Gentleman Farmer or a Playboy?

Genet decided to make the best of things in America. With his wife and six children, he lived the idyllic life of a gentleman farmer in East Greenbush. Business was not Edmond's forte—he lost heavily in speculative investments such as plaster manufacturing, wool processing and the Highland Turnpike Company, which ran a stage route up and down the Post Road (he apparently was a friend of John Kinney, one of the company's owners, in Kinderhook). It seemed that a sharp trickster could talk him into anything.

Prospect Hill served as his homeport for casual or formal visits to wealthy neighbors up and down the Hudson or to New York City. He and his wife would travel by river steamer or perhaps a carriage trip down the Post Road. Leaving the children in the care of a nanny, they were always welcome guests anywhere they went, with Cornelia's beauty and political connections and Edmond's intriguing French accent, harpsichord playing, singing and storytelling. The Genets would often call at the grandest estate of them all, Hyde Park, on the east bank of the Hudson, fifty miles south of Prospect Hill. The owner was Dr. Samuel Bard and later, after 1828, Dr. David Hosack. An interesting story has come to light connecting Dr. Hosack and Edmond Charles Genet. In 1835, Harriet Martineau, a visitor from England, wrote about Hyde Park, "Among the ornaments of his house I observed some biscuits [earthenware or porcelain after a first firing and before glazing] and vases once belonging to Louis XVI, purchased by Dr. Hosack from a gentleman who had them committed to his keeping during the troubles of the first French Revolution." Was the "gentleman" Genet, and how did he come by the biscuits and vases? Perhaps they were part of Louis XVI's belongings that had been placed on board the *Embuscade* at Brest before Genet made his escape from France without the king on the ship.

Cornelia died in 1810, leaving Edmond and six children to mourn her death. Edmond took her loss hard, but after a couple years he began to seek a companion for himself and a mother for his children. He was welcomed even more graciously by Hudson River and other wealthy families now that he was single. He wrote to his sister in France, "At first I reckoned 24 girls or young widows whom I admired and who seemed

willing to regenerate my former happiness, but as I am not a Turk and could not marry them all I have by degrees reduced the number to three, to wit one in Albany, one in Poughkeepsie and one here, they are all three accomplished, captivating and wealthy"[78] Actually choosing none of those three, he finally married Martha Brandon Osgood, a Washington socialite and daughter of the postmaster general. He apparently chose well because his life continued along a happy path.

GENET'S "SCIENTIFIC" THEORIES AND INVENTIONS

In 1825, the same year that the Erie Canal[79] was opened, Edmond Genet's theories and inventions were published by an Albany printing company, Packard and Van Benthuysen. Genet's *Memorial on the Upward Forces of Fluids*[80] was America's first book on aviation, and that fact alone gave the work great significance. With its scientific language and illustrations, the book must have appeared very scholarly to the uneducated masses of the early nineteenth century. But Genet's contemporary scientists, inventors and mathematicians criticized the book from the beginning as nothing more than a collection of crackpot ideas. The most ludicrous theory, which was repeatedly mentioned in the book, was Genet's theory of levity, an anti-gravity force. Any person (except Genet and his publisher) with any knowledge of physics could understand that what Genet thought was levity was actually the principals of centrifugal force and the expansion of gases as they were heated.

Six inventions were illustrated in his book, five of which had some connection (although useless) with canals. His first wife's family, the Clintons, was probably pleased and may have helped him pursue his ideas. As the first illustration in the book, an "Aerostatic Elevator" was intended to pull canalboats up an inclined plain. The next, a "Hyrostatic Vertical Elevator" was again intended for use on canals, this time lifting a canalboat without the use of a lock. The third invention pulled canal boats using a "Hidrostatic Tractor." Next, a "Hydronaut" was used to power a boat, similar to a steam engine side-wheeler. The last plate in the book was probably an afterthought, because it involved no steam, levity, "hydronauts" or "aeronauts." It was a simple device "to protect steamboats against snags, planter, sawyers, shoals, rocks, etc."

The fifth illustration was perhaps the most fanciful of all. It showed an "Aerostatic Vessel or Aeronaut," which in simple terms was a hot air balloon powered by two horses running on a circular treadmill. Genet must have gotten his idea for this contraption by watching the horse ferryboats, which had similar horsepower, as they plied the Hudson River between Greenbush and Albany at the northerly terminus of the Post Road.

"Two Horses in the Sky"

The *Aeronaut* deserves special mention. Since his invention was based on seemingly brand-new theories, Genet was able to make some grandiose statements about his hot air balloon powered by "two horses in the sky." His *Upward Forces of Fluids* made the following points:[81]

> *In point of safety, the aerial navigation has a decided advantage over land and water; because...neither lives nor goods, if the aeronauts are well-constructed and the navigators prudent, will be exposed by the fall of the machine to any of the accidents which so often happen by water or by land, and on the water too frequently without remedy; and because the whole machine, as I have planned it, being entirely covered with oiled silk, will be perfectly secure against electrical fires...the extent of the deck and platform are such, in the present plan, that in combination with the air cutter and wings, they would form an immense parachute, and the downfall of the machine would consequently be lighter than the fall of a feather.*
>
> *...In point of steadiness, aerial navigation would be superior to inland water communications; it not being subject to interruptions by the frost of winter, or the droughts of summer, or any accident creating a solution of continuity in the water ways.*
>
> *...In point of economy, aerial conveyance would be a great deal cheaper than any land or water transportation; as there will be no toll, nor other necessary expenses of the land carriage, to pay in the air.*
>
> *...In point of celerity, all the odds will be on the side of the aerostats; because they will not always have to react against contrary winds; and that it is well known, that their progress, with a favourable current, in a straight horizontal course, is extremely rapid.*[82]

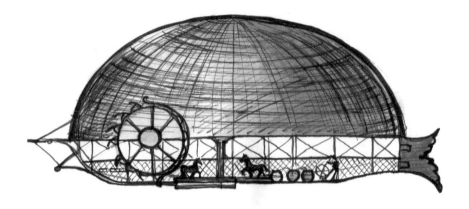

Two horses in the sky.

Of course, the idea of floating "two horses in the sky" wasn't practical:

> *With all his acquired and theoretically applied aeronautical knowledge, it does not appear that Edmond Genet ever set foot off the ground in a balloon. He simply did not have the money and materials to build one. Albany was treated to a balloon ascension in celebration of the fourth of July in 1826. The following year, Genet fully expected to actually construct a self-propelled and guided "aeronaut" with the aid of a fellow-countryman, the celebrated French free balloonist Eugene Robertson. Unfortunately, Robertson found lucrative exhibition work in the Southern states, and nothing came of the project. It was not until 1852 that a guided, true dirigible was actually flown.*[83]

EDMOND GENET'S DESCENDANTS (GOOD, BAD AND VERY GOOD)

Three generations of Edmond's decedents have found places in history books. Henry J. Genet, one of Edmond's sons, was a major general in the state militia and a member of the state legislature.

A grandson, Henry W. Genet, made history in a different way—which, for a time, disgraced the Genet family name. Henry W. was a close associate

of "Boss" William Marcy Tweed in New York City and in December 1873 was convicted of "stealing city building supplies and funds by submitting fictitious work vouchers."[84] The *New York Times* called him "one of the most vulgar, brutal, and defiant of the [Tweed] Ring conspirators." Hours before his sentencing, Henry W. escaped from his home through a back window. Somehow he made his way to Canada and eventually to Europe.

A great-great-grandson, Edmond Charles Clinton Genet, redeemed the family reputation many years later. In January 1915, he left his Post Road home in Ossining, New York, to join the French Foreign Legion during World War I. After four generations, he and his family still felt strong attachments to their French heritage, and Edmond gladly entered the fight against Germany. "I expect to have to give up my life on the battle-field. I care nothing about that. Death to me is but the beginning of another life—better and sweeter. I do not fear it."[85] After fighting in the bloody battle of Bois Sabot (where he was one of thirty-one survivors out of five hundred soldiers) in September 1915, he joined the first group of Americans in the Lafayette Escadrille, the American flying squadron, which was part of the French forces. On April 17, 1917, young Genet became the first American flier to die after the United States officially entered the war. His mother received the French Croix de Guerre for him, as well as a personal tribute from President Woodrow Wilson.

Posthumous Honors

Edmond Charles Genet Sr. died on July 14, 1834 (Bastille Day in France, the counterpart of the Fourth of July in the United States). For a person of such importance during his lifetime, honors given to Citizen Genet after his death have been meager. The East Greenbush chapter of the Order of the Eastern Star, as well as the East Greenbush Middle School, is named after Citizen Genet. He is buried at the East Greenbush Reformed Church cemetery just off the Post Road next to his two wives, but there is no record that he was a member of that church or even attended services there. It is a mystery that rests with him in the grave.

War of 1812 Cantonment Greenbush

About five miles east of Albany, the New York–Albany Post Road intersects with the Boston–Albany Post Road. Joined together, the two post roads then begin a slow descent in a westerly direction to the Hudson Valley. Along the way, there has always been a spectacular view of the city of Albany, formerly the village of Albany, before that Beverwyck and before that Fort Orange. About a mile before the river was the site of the encampment of six thousand American soldiers at the beginning of the War of 1812. According to historian Benson Lossing, "From that spot went companies and regiments to the northern frontiers in 1812–14, to invade Canada, or to oppose an invasion from that province, as circumstances might require."

Since the year 1812, the encampment, also known as Cantonment Greenbush, has been one of the most historic places in the town and, for that matter, anywhere along the Post Road. *Landmarks of Rensselaer County* by George Baker Anderson, published by D. Mason & Company in 1897, had a very detailed description of the grounds:

> *The troops, which first arrived, were quartered in tents, but the construction of permanent buildings was immediately begun. The buildings were of wood, substantially built upon stone foundations. There were eight of them, 252 feet long, 22 feet wide and two stories*

high, and they were arranged four upon each side of a parade ground. The quarters of the regimental officers, of which there were four,[86] ninety feet long and two stories high, were ranged at right angles with a soldiers' barracks. On the north of this group of buildings near by stood two large commissary store houses, and the barracks master's dwelling. A short distance to the east of the storehouses stood the brick arsenal, a fire proof building, and on the summit of the hill commanding a view of the entire camp, as well as extensive range of country on either side, were the general's headquarters, the hospital and surgeons' headquarters, three large two-story buildings each 90 feet long. Besides the buildings enumerated, there were a number of buildings of smaller size, among which were the ordinary and provost guard houses, seven large detached cooking houses and several machine shops.

There were also extensive stables and other less important buildings. The structures were all painted white and in their elevated positions were very conspicuous.

"Uncle Sam"

According to *Yesterday and Today*, a publication of the East Greenbush Sesquicentennial Committee in 2005, "This Cantonment was the

Officers' quarters at Cantonment Greenbush, 2008.

birthplace of our mythical 'Uncle Sam,' a name adopted by the troops who called the beef marked 'E.A.-U.S.' ('E. Anderson' [in charge]—'United States') shipped to the Army by the butcher Samuel Wilson of Troy, 'Uncle Sam's beef.'"[87]

AN EXECUTION

A soldier's life at the Cantonment was difficult, despite all the modern buildings and "Uncle Sam's" beef. Soldiers were constantly deserting because of boredom, hardship or loneliness. A story told by a visiting medical officer in *Landmarks of Rensselaer County* details a heartbreaking tale about life (and death) in the camp:

In 1814 I was stationed with a detachment of United States troops at Greenbush in the State of New York. One morning several prisoners, confined in the provost guard house, were brought out to hear the sentence, which a court-martial had annexed to their delinquencies read on parade. Their appearance indicated that their lot had been sufficiently hard. Some wore marks of long confinement, and on all the severity of the prison house had enstamped its impressions. They looked dejected at this public exposure and anxious to learn their fate. I had never seen the face of any of them before, and only knew that a single one of them had been adjudged to death. Soon as their names were called and their sentences pronounced, I discerned by his agony and gestures the miserable man on whom that sentence was to fall, a man in the bloom of youth and the fullness of health and vigor.

Prompted by feelings of pity, I called next morning to see him in prison. There, chained by the leg to a beam of the guard house, he was reading the bible, trying to prepare himself, as he said, for the fatal hour. I learned from him the circumstances of his case. He was the father of a family, having a wife and three young children thirty or forty miles from the camp. His crime was desertion, of which he had been three times guilty. His only object in leaving the camp in the last instance was to visit his wife and children. Having seen that all was well with them, it was his intention to return. But whatever was his intention, he was

a deserter, and as such taken and brought into the camp, manacled and under the guard of his fellow soldiers. The time between the sentence and his execution was brief; the authority in whom alone was vested the power of reprieve or pardon distant. Thus he had no hope, and only requested the attendance of a minister of the gospel and permission to see his wife and children. The first part of his request was granted, but whether he was permitted or not to see his family I do not now remember.

Dreading the hour of his execution, I resolved, if possible, to avoid being present at the scene. But the commander of the post, Colonel L., sent me an express order to attend, that, agreeable to the usage of the army, I might in my official capacity as surgeon see the sentence finally executed.

The poor fellow was taken from the guard house to be escorted to the fatal spot. Before him was his coffin, a box of rough pine boards, borne on the shoulders of two men. The prisoner stood with his arms pinioned between two clergymen; a white cotton gown, or winding sheet, reached to his feet. It was trimmed with black, and had attached to it over the place of the real heart the black image of a heart, the mark at which the executioners were to aim. On his head was a cap of white, also trimmed with black. His countenance was blanched to the hue of his winding sheet and his frame trembled with agony. He seemed resolved, however, to suffer like a soldier. Behind him were a number of prisoners, confined for various offenses; next to them was a strong guard of soldiers with fixed bayonets and loaded muskets. My station was in the rear of the whole.

Our procession was formed, and with much feeling and in low voices on the part of the officers we moved forward with slow and measured steps to the tune of the death march [“Roslyn Castle”] played with muffled drums and mourning fifes. The scene was solemn beyond the powers of description. A man in the vigor of life walking to the tune of his own death march, clothed in his burial robes, surrounded by friends assembled to perform the last sad offices of affection, and to weep over him in the last sad hour; no, not by these, but by soldiers with bristling bayonets and loaded muskets, urged by stern command to do the violence of death to a fellow soldier. As he surveys the multitude he beholds no look of tenderness, no tear of sensibility; he hears no plaint of grief; all, all is stern as the iron rigor of the law, which decrees his death.

Amid reflections like these we arrived at the place of execution, a large open field, in whose center a heap of earth, freshly thrown up, marked the spot of the deserter's grave. On this field the whole force then at the Cantonment, amounting to many hundred men, was drawn up in the form of a hollow square, with the side beyond the grave vacant. The executioners, eight in number, had been drawn by lot. No soldier would volunteer for such a duty. Their muskets had been charged by the officers of the day, seven of them with ball, the eighth with powder alone. Thus prepared they were placed together and each executioner takes his choice. Thus each may believe that he has the blank cartridge, and therefore has no hand in the death of his brother soldier; striking indications of the nature of the service.

The coffin was placed parallel with the grave and about two feet distant. In the intervening space the prisoner was directed to stand. He desired permission to say a word to his fellow soldiers, and thus standing between his coffin and his grave warned them against desertion, continuing to speak until the officer on duty, with his watch in his hand, announced to him in a low voice: "Two o'clock, your last moment is at hand; you must kneel upon your coffin." This done the officer drew down the white cap so as to cover the eyes and most of the face of the prisoner, still continuing to speak in a hurried, loud and agitated voice. The kneeling was the signal for the executioners to advance. They had before, to avoid being distinguished by the prisoner, stood intermingled with the soldiers who formed the line. They now came forward, marching abreast, and took their stand a little to the left, about two rods distant from their living mark. The officer raised his sword. At this signal the executioners took aim. He then gave a blow on a drum, which was at hand. The executioners all fired at the same instant. The miserable man, with a horrid scream, leaped from the earth and fell between his coffin and his grave. The sergeant of the guard a moment after shot him through the head with a musket reserved for this purpose in case the executioners failed to produce instant death. The sergeant, from motives of humanity, held the muzzle of his musket near the head; so near that the cap took fire, and there the body lay upon the face, the head emitting the mingled fumes of burning cotton and burning hair. O war, dreadful even in thy tenderness; horrible in thy compassion!

I was desired to perform my part of the ceremony, and placing my hand where just before the pulse beat full and life flowed warm, and finding no symptom of either I affirmed "He is dead." The line then marched by the body, as it lay upon earth, the head still smoking, that every man might behold for himself the fate of a deserter.

Thus far all had been dreadful indeed but solemn, as it became the sending of a spirit to its dread account; but now the scene changes. The whole band struck up and with uncommon animation our national air, "Yankee Doodle," and to its lively measures we hurried back to our parade ground. Having been dismissed the commander of the post sent an invitation to all the officers to meet at his quarters, whither we repaired and were treated to a glass of gin and water. Thus this melancholy tragedy ended in what seemed little better than a farce, a fair specimen—the former of a dead severity, the latter of the moral sensibilities which prevail in camp.

The President Who Wasn't Great, Just "OK"

Martin Van Buren of Kinderhook

There is a white milepost (number 134) in a neatly trimmed lawn along the Post Road about fifteen miles south of the city of Albany. Set back from the road and milestone stands a magnificent two-story Georgian-style brick home. In the rear of the house, a four-story widow's watch towers over the rest of the building. It is obviously a very old and important house—in fact, it has been restored by the State of New York as a museum depicting the relatively quiet period of United States history between the Revolutionary War and the Civil War. It is the second of two presidential mansions on the Post Road (the other is located in Hyde Park, the home of President Franklin Delano Roosevelt). This place near Kinderhook, called Lindenwald, was the retirement home of President Martin Van Buren.

The location of Martin Van Buren's birth in 1782 was two miles north on the southeastern edge of the hamlet of Kinderhook, on the south side of the Post Road, in a small room above his father's tavern and stagecoach stop. The tavern was a long clapboard building with fieldstone chimneys on each end. The building was also Kinderhook's polling place, and when the village's men weren't voting, they would debate politics while sitting in front of the two fireplaces. All this would be absorbed by the young Martin Van Buren.

Martin's impoverished childhood seems to have been the impetus for his dedication in pursuing a climb up the political and social ladder to

Van Buren tavern in Kinderhook, New York.

the very top: the presidency of the United States. At the age of fourteen, Martin began his climb. Taking a job cleaning the fireplaces and sweeping the floor for a local lawyer, Martin slowly began to learn the language and methods of the law profession. At sixteen, he moved to New York City to assist and study under another former Kinderhook lawyer, William P. Van Ness, the builder of Lindenwald and the man who is best known as Aaron Burr's second in the famous duel with Alexander Hamilton in 1804.[88] Martin returned to Kinderhook in 1803 and was admitted to the bar. His career took off in 1808 when he was elected surrogate judge of Columbia County; then in 1812 he was elected to the state Senate and then as state attorney general, governor and U.S. senator. Then he was appointed secretary of state and minister to England and then elected vice president and, finally, president in 1836.

"OK"

All along the climb, his amazing political instincts always moved him further up the ladder. He was a master of political intrigue and maneuver, and politics was his consuming passion. Besides the passion, a certain

amount of paranoia entered Van Buren's life; he was known to carry two loaded pistols with him at all times while he was vice president. Several derogatory nicknames—such as the "Little Magician," "Little Van" (he hated both nicknames because of the reference to his short height) the "Red Fox of Kinderhook," the "American Talleyrand,"[89] the "Prince of Villains" and the one he liked best, "Old Kinderhook"—were attached to him at a time when nicknames were popular in political circles. Van Buren even began approving memos and other nonofficial documents with "OK," short for "Old Kinderhook." The "OK" seemed to have struck a chord with the general public and has become, even today, perhaps the most universally recognized expression in the world.

TROUBLED PRESIDENCY

Like many career politicians, Martin Van Buren was better at obtaining office than he was an officeholder. As vice president, Van Buren supported President Andrew Jackson's policy of abolishing the Bank of the United States and, as a consequence, was partly to blame for the financial Panic

Martin Van Buren.

66

of 1837. His own presidency suffered badly because of it. Other problems during his four years in the White House were also self-created.

Whether a person was proslavery or antislavery was an all-important issue, one that ultimately was only resolved after the horrible cataclysm of the Civil War. To Van Buren's credit, he delayed the war but, in the process, alienated everybody, North and South. While he was a U.S. senator, he was against slavery in the Florida territory, so he lost the favor of the South. While he was president in 1839, he took the opposite tack and incurred the hatred of many people in the North. Fifty-three slaves from Africa had taken over a Spanish slave ship, the *Amistad*, and had made landfall in Connecticut. Van Buren opposed the slaves' release or return to Africa. In a Connecticut courtroom, the escaped slaves won their case, and Van Buren's reputation again suffered.

BEATEN AT TRY FOR A SECOND TERM

Widower Martin Van Buren was practically sung out of office when he ran for a second term in 1840. Because of his fondness for the social life of Washington, D.C., he earned the reputation of being a "dandy." William Henry Harrison, who had spent most of his life in the backwoods of the American West, and who was celebrated in campaign songs as the future "log cabin" or "hard cider" president, easily beat out Van Buren when the electoral votes were counted. The irony of the election was that Harrison, who was born in a mansion in Virginia, beat Van Buren, who was born above a tavern (exactly the opposite of what the electorate assumed).

FORCED RETIREMENT

Van Buren's retirement at his home on the Post Road was restless for the first few years (he ran for president again in 1844 and 1848), but he gradually learned to love Lindenwald. He lived the life of a country gentleman, and it seemed like the Lindenwald parlors were always occupied with important political or literary guests. James Fenimore Cooper, Samuel F.B. Morse, Winfield Scott, Aaron Burr, James Kirke

Paulding, William Seward, Henry Clay and others all came for visits. Washington Irving would stay for weeks at a time and find inspiration in the home that he had visited decades earlier when it belonged to "Old Judge" Van Ness. Irving would entertain Van Buren with tales of the Moors and the Alhambra in Granada, Spain, or of his other travels in Europe and the American West.

It is easy to imagine Van Buren and his guests sitting on Lindenwald's grand eastern porch watching the traffic on the Post Road. They would eagerly await the daily New York and Albany stagecoach as the "coachy" would toss down the latest issue of the New York or Albany newspaper while "on the fly." They would also see

> *two-wheeled carts, drawn by oxen, go lumbering along; the one-horse shay; the stout horse with saddle bags, ridden by an old gentleman with spectacles and wig in a brown coat with baggy pockets bulged out with bottles of medicine, that most beloved of all the travelers on that road, the country doctor…and most curious of all, the farmer and his wife, riding the same horse, the man in front and the woman behind, "riding a pillion." Besides these vehicles and horses [they] saw many people "on foot," for the majority of the travelers of those days were accustomed to use "shanks' mare" and thought nothing of walking fifteen or twenty miles a day.*[90]

ROLE MODEL FOR LOCAL BOY

John Ward Cooney, the son of a Lindenwald employee, wrote the following:

> *As a boy of twelve I knew Mr. Van Buren as a kind and considerate employer, a pleasant and genial older man who stood high in the estimation of all who came into contact with him.*
>
> *Like many great men, Mr. Van Buren seemed to find his chief recreation in fishing and outdoor tramps across the country. On such occasions I was his constant companion, carrying his lunch basket or fishing-rods and guiding him to the best fishing spots. Because of this, village youngsters labeled me as the "president's boy." Resenting this, I was often in fights with other boys with black eyes to prove it!*

Henry Clay, Van Buren's
friend.

The President enjoyed inviting Henry Clay,[91] Commodore Singleton and other friends to fish with him. One day while busy weeding onions, I was asked to catch some bait so they could go fishing. I grumbled that I hadn't been paid well for the last bait I got for him! Put on the spot, Mr. Van Buren protested that I was being unfair to him. Henry Clay and his other companions roared with laughter at his embarrassment and took up a collection to assure proper payment. And what a great fishing expedition we had after that![92]

GENTLEMAN FARMER

Following Van Buren's defeat in the 1840 election and his return to Kinderhook he busied himself in improving his property. In an article in the New York Commercial Advertiser, a reporter stated: "There was a garden to be made and fences to be set up, paths to be laid out and decayed fruit trees to be replaced; meadowlands overgrown with dwarf alders to be reclaimed."

Lindenwald.

Thus far the state of the farm does credit to his skillful administration. A large garden has been laid out, with a green house, and a long wall for the protection of fruit trees, a copious spring has been made to supply a succession of fish ponds, and the process of making into good meadows the moist lands covered with useless bushes, is going on with great activity. A great variety of young pear trees, ordered from Hamburgh eight weeks before are now in the ground, healthy and flourishing.

The ex-President begins the day with a ride of ten or fifteen miles on horseback; after breakfast he is engaged with workmen till he is tired, and then betakes himself to the library, which he is constantly enlarging.

A William Paulding[93] *letter from 1847 states: the attention to meadow lands and the priority placed upon reclaiming swamp and wetlands by ditching was costly. However, the return was great. The "Muck Beds"…provided a source of natural fertilizer and scientific curiosity when intact birch bark and charcoal were recovered from seven feet below the surface. A professor Cooney was called upon to investigate this. Van Buren stated that reclaiming the meadow involved "a thousand miles of ditches by the aid of an old Englishman and four paddies, at the cost of 500 dollars."*

A few months after this, in June 22, 1848, Van Buren proudly reported: My farm contains only 225 acres & I have under the plow

82 acres viz.—30 in rye (we sow no wheat here) 20 corn 28 oats & 4 potatoes—24 in fine clover for pasture and 85 in fine Timothy & a few acres of clover for cutting. If you want to know how they all look, come and see. I say nothing of my garden & nursery & orchards, but…have 15,500 young apple trees & 2000 young pear trees for sale.[94]

MARTIN'S SON, JOHN VAN BUREN

John Van Buren was state attorney general at the time of the culmination of the anti-rent riots in Columbia County. As such, he was the lead prosecutor in the 1845 trial of the leader of the anti-rent rioters, Smith Boughton (also known as "Big Thunder"), in the city of Hudson. Martin Van Buren had defended the anti-renters during his early political career, but his son was square on the side of the landlords. Martin attended some sessions of the trial and witnessed his son disgrace the family name. The following courtroom scene took place between John Van Buren and Ambrose L. Jordon, elderly defense attorney for Boughton:

"Prince" John Van Buren.

71

"That is false."

"You're a liar."

Van Buren swung his forearm backward from the elbow, catching Jordon across the face. The old man came out of his chair fighting, his fists flailing at his shorter, younger opponent. "Order!" yelled Judge Edmonds. "Order! Stop them, stop them!" Officers grabbed the slugging men and forced them back into their chairs.

Judge Edmonds ordered the attorneys to jail for twenty-four hours for contempt of court. Contritely John Van Buren apologized and begged that a fine be substituted for imprisonment. The request was refused. The gaunt Ambrose Jordon said…"As this affair has happened here in a court of justice I regret it…I have, however, no whining apology to make nor any favors to ask except this, that the court will do me a favor to confine us both in the same room."[95]

John Van Buren was also rumored to have had a later sexual affair with Queen Victoria and was himself nicknamed "Prince John." After Martin Van Buren's death, John lost the title to Lindenwald while gambling. "The winner was New York City financier, Lawrence Jerome, whose daughter was Jenny Jerome, Winston Churchill's mother."[96]

LINDENWALD GHOST STORIES

Like many old and famous houses, Lindenwald has a few good ghost stories. The following appeared in the *Hudson Register-Star* in October 1963:

An old Lindenwald servant (having just consumed a quantity of hard cider) claimed that, as he was returning to his work at the barn, he saw a fastidiously arrayed gentleman in knee breeches whose appearance was exactly like (Aaron) Burr's. The figure went skipping blithely along the path, but, at the sound of a hard clap of thunder, suddenly turned a series of amazing handsprings, grew smaller and smaller, and disappeared down a woodchuck hole.

Others profess to have seen Aaron Burr's ghost down in Lindenwald's orchard, dressed in a wine colored coat and a shirt with long ruffled

sleeves. This sight was most often visible when a summer storm was brewing, and no matter how much the wind blew, the billowy sleeves never moved. There is no doubt that this is Lindenwald's most eminent ghost. But it has others. There is Martin Van Buren's old butler who used to sneak off to the orchard for a snort of applejack. One day he hanged himself from an apple tree, and some say they have seen him down there with his jug, or swinging from his rope.

The ghost of the woman murdered in the gatehouse is quite ordinary, simply flitting about near the roadway. But some have more imagination! Like Aunt Sally. She was Martin Van Buren's cook for many years, and it was said she ruled the kitchen "like a queen." Everything was immaculate, and any servant who idled was liable to feel the strong hand of her displeasure. After her death, if she came back and found her kitchen dirty, she would throw all the pots and pans on the floor and cuff the servant who was to blame. Occasionally, residents of Lindenwald would wake up to smell pancakes baking. But a quick trip to the kitchen would reveal only a cold stove. Then they knew Aunt Sally was around, still keeping a watchful eye on the household.

Anti-Rent Wars in Columbia County, 1751–1852

Lords and Tenants

Several anti-rent riots, murders, kidnappings and threats occurred in Columbia County in the period of 1751–1852. The major cause of the riots was the fact that large landholders (mainly the Livingston family) owned most of the land in Columbia County, and the renters wanted it. Some renters had lived and farmed on the land for several generations with nothing to show for it. They were little better off than slaves or serfs. Some historians have even traced the landlord-tenant dispute back as far as 1711, when "Governor Robert Hunter ordered 130 soldiers to the vicinity of the 'East Camp' to awe and disarm the mutinous tenants there."[97] Fanning the flames of this landlord-tenant problem was a dispute between the colonies (and later states) of New York and Massachusetts.

Colonial Land Claims

Surveys of the two colonies had overlapped. The Massachusetts claim went as far west as the Hudson River, and the New York claim went as far east as the Connecticut River. This land dispute simmered for decades and finally turned into open hostility in 1751. Several Livingston

Robert Livingston Jr.

manor tenants were in arrears for rent, and many refused to pay. "Robert Livingston, Jr., grandson of the first proprietor, was then in possession. The tenants based their refusal, to some extent at least, upon the ground that Massachusetts owned the land."[98] Violence erupted when employees of Robert Livingston Jr. burned down the home of George Robinson, a tenant who refused to pay his rent. Livingston even had Robinson arrested for "trespass in carrying away Livingston's goods." Livingston also accused Massachusetts of "aiding and abetting said trespass." For four years, the situation remained the same—Robert Livingston, Jr. fought a risky, one-landlord battle against most of his tenants.

The class struggle was as bad as any feudal struggle in Europe. "While the manor store provided the tenants with a diet of 'molasses, rice and limited spices,' the Livingston family enjoyed 'such delicacies as sweet oil, raisins, currants, cloves, cinnamon, cheeses, oysters, mint wafers, figs, olives and capers.'"[99] The Livingston family lived in an insulated

world, entertained important guests and had little idea of the problems of their tenants. While the tenants often lived in squalor, "Great treasures of tapestries, pictures, inlaid cabinets, jewels, satins, velvets and laces, as well as old wines, delicate porcelains and expensive plate [were] imported by the family. For miles along the eastern bank of the Hudson, above and below what is now Rhinebeck, almost every sightly eminence was capped with a fine residence of one of the grandchildren of the first Lord and Lady of Livingston Manor."[100]

VAN RENSSELAER MANOR

The owners of the Van Rensselaer manor joined the dispute, and posses from both the landlord side and the tenant side began to do battle. The first death occurred when William Rees, a Livingston tenant, was shot by a Van Rensselaer posse rider. "The killing of Rees seems to have intensified the bitterness of feeling on both sides, but more particularly among the opponents of Livingston and Van Rensselaer."[101] In 1757, a riot took place in Taghanic in which two renters were killed and several wounded. In 1766, the renters got their revenge when they gathered a large posse and killed several men attached to the Albany County sheriff's posse. Two hundred tenants had marched to "murder the Lord of the Manor [Livingston] and level his house."[102]

REVOLUTIONARY WAR

During the Revolution, violence intensified, and the Livingston manor struggle became a Tory v. Patriot fight. Like every war, many neighbor v. neighbor blood feuds were settled by killing the neighbor and blaming it on the war. This certainly happened in Columbia County, but there was also a very serious recorded event that could have completely changed the outcome of the Revolutionary War. Because most of the landlords in Albany (later split off as Columbia) County had joined the Patriot cause, almost all of the tenants took sides with the Tories. In the spring of 1777, it appeared that the British were winning the war as they were

sending warships unmolested up the Hudson River from New York City. Numerous (but untrue) reports from British spies convinced the tenants that the time was right to strike at the landlords. In May 1777, a great tenant rising occurred when hundreds of tenants made menacing actions, such as threatening to burn down Livingston's mansion. However, their moves were poorly timed and poorly equipped. They really didn't have a chance as Continental troops and militia quickly suppressed them. If they had waited another four or five months to rise up and fight, they would have drained away enough troops from the Continental army so that perhaps Burgoyne would have won the Battle of Saratoga. If the British had won that battle, they probably would have won the war.[103] Livingston's mansion did get burned to the ground, not by the tenants, but by British general John Vaughan on October 16, one day before the surrender of Burgoyne.[104]

SHERIFF HOGEBOOM

In 1791, Sheriff Cornelius Hogeboom was cold-bloodedly murdered by a tenant farmer as the sheriff was trying to auction off the tenant's possessions. He was shot through the heart as an angry mob chased him down. The murderer and three of his associates escaped into Canada, but twelve other tenants and tenant sympathizers were jailed at Claverack (probably at the Muller house, the same house that was used as a prison in the Revolutionary War) on the Albany Post Road. In February 1792, they were all tried and acquitted. Hogeboom had been a popular sheriff, and his tragic death strangely put an end to similar violent acts for several decades.

"BIG THUNDER" AND THE CALICO INDIANS

The tenants' desire to gain title to their lands was not dead, however. Instead of a violent cause, it became a political cause. Tenants in the counties of Albany, Columbia, Greene, Ulster, Delaware,[105] Schoharie, Herkimer, Montgomery, Otsego, Oneida and Rensselaer all caught

"Big Thunder."

the spirit of anti-rentism. They met, elected leaders and, by 1840, had formed secret organizations:

> *Bands of men pledged themselves to meet whenever called upon to protect tenants from arrest. If a sheriff appeared in any particular locality, he was met by a troop of men fantastically dressed (in calico clothing), with masked faces, and armed with a variety of weapons, who gathered about and by warnings and threats, prevented him from doing his duty.*[106]

On one occasion, on December 12, 1844, Sheriff Henry C. Miller encountered

> *hundreds of masked men in swinging calico dresses. Red, blue, yellow sheepskin masks, on which grotesque eyes, spread noses, contorted mouths had been painted in contrasting hues, covered heads and necks. Dresses "made like a woman's nightgown" hung below the men's knees, brilliant in solid colors, bold figures, garish stripes. Calico pantaloons, large and full, showed above boots that had weathered many plowings. From fancy belts hung silken tassels, rattle-snake skins, bright tin horns*

Calico "Indians" in full regalia.

that gleamed and jingled in the marching. Each man carried a weapon in
his hands; spear, tomahawk, pistol, club, pitchfork, or rifle.[107]

They were under the leadership of one called "Big Thunder" (Smith A.
Boughton). Big Thunder and associates burned the eviction and auction
papers in front of the sheriff, who was held by a group of the "Indians."
They had alerted one another by sounding the alarm on tin horns. The
shrill sound of the tin horns could be heard up and down the Post Road
and would strike fear in the hearts of landlords and their agents.

Sheriff Miller returned to the city of Hudson, where his report
excited great indignation. After another incident a week later on
December 18, when a man was accidentally killed at one of "Big
Thunder's" speeches, the people of Hudson decided to have him
arrested. The social class struggle, which had become a landlord v.
tenant dispute, which became a Tory v. Patriot dispute, which became
a state v. state dispute, now became a city v. country dispute. After
"Big Thunder" and twelve other anti-rent leaders were arrested and
jailed in Hudson, "it was reported that a thousand men from the
eastern part of the county had threatened to rescue the prisoners
and burn the city."[108] The city was never attacked, however, because
various militias from other counties immediately came to the city's
defense. "Big Thunder" was convicted of destroying public property

(the eviction papers that Sheriff Miller had tried to serve on December 12, 1844) and sentenced to imprisonment for life by the judge, who was obviously not an anti-rent sympathizer.

AN ELECTION CHANGES EVERYTHING

By 1846, sentiments again had swung in favor of the anti-renters. They formed an anti-rent political party and even managed to elect their man, John Young, governor of the state of New York. His first official act was to pardon all the anti-renters who had been sent to prison (including "Big Thunder"). In 1852, the dispute, which had blown hot and cold for 101 years, was finally put to rest. The state's highest court, in the case *De Peyster v. Michael*,[109] decided once and for all against the manorial claims of Livingston and others. What the tenants failed to gain with the gun, they gained in court. Most of the land occupied by the tenants for a certain number of years was declared real property of the tenants, not the landlords.[110]

A Long Night in Poughkeepsie

With all of the stories in history books about rioting in New York City, the truth is that several riots have occurred farther north in the Hudson Valley. A case in point is a terrible incident that occurred in Poughkeepsie (eighty miles up the Post Road) in 1850. Many settlers in the Hudson Valley had suffered economically for years and had no love for any newcomers who might work for cheaper wages and take their jobs. At the time, thousands of destitute Irish had arrived by the boatload at New York City Harbor. Many had made their way up the newly constructed Hudson River Railway to Poughkeepsie, the first sizable village north of New York City.

One Saturday night in January 1850, a serious fight broke out between some townsfolk and a group of Irish immigrants. The immigrants were beaten severely with clubs, while the police reportedly watched from a safe distance. According to the *Poughkeepsie Journal and Eagle*, "On Monday night, the Irish, or some fifteen or twenty of them collected in Union Street [two blocks west of the Post Road], and having charged themselves with liquor—three or four were foolish enough to arm themselves with guns. At about 8 o'clock they attacked a black man and woman in the street—the man ran away, leaving the woman behind, who got slightly injured." The sheriff arrived but was alone, unfortunately. He was menaced and chased down the street. Watching

1850 Poughkeepsie, with Justice Building in center.

the excitement from Grand Street were five or six townsfolk, one of whom was shot in the chest.

After this, "The alarm now spread all over town—the bell was rung and people were running in all directions." Townspeople with rifles arrived and arrested the drunken Irishmen, and the whole incident could have ended at that point. Instead, two companies of militia arrived, and several hundred citizens showed up "armed with pistols, slug shots, clubs, pickets, sword-canes, etc."

"After the arrest of the Irishmen in the street, the townspeople—unauthorized by any law—began a system of proceedings which can be compared to nothing more striking than an Indian descent upon a defenseless settlement."

The mob forcibly entered private homes where Irishmen lived, dragged people out of bed and beat many of the innocent residents with clubs. Many Irishmen were forced half-naked into the street and "arrested." Most were marched, some barefoot, to the Justice Building on the Post Road.

The next morning, the difficult task of sorting out the fifteen or twenty drunken Irish rioters from the dozens of innocent people began. It was clear to everybody in the courtroom that the innocent people had suffered much more than the actual rioters. All of the Irish victims were released

and received a lot of pity from townsfolk in the courtroom. Perhaps out of shame from what had happened, several of the poor barefoot Irish victims were given shoes. The rioters were "committed," but no mention was made in the paper of the punishment or lack of punishment that was given to the hundreds of people who invaded the Irish homes.

As was customary at the time, the newspaper account of the riot included a lot of editorializing:

> *The worm will turn when trod upon, and if peaceable, quiet Irishmen must be deprived of mercy and justice, and liberty, because of the fault of a few, they will face no better here than under oppressive English rule, and in the end we need not look to them for anything but revenge and personal hostility in return.* The reporter also noted that *the name of our village is getting abroad—the magnetic telegraph sent to New York that rioters were in prison—stories have gone all over the country that murder and riot prevailed at Poughkeepsie, also other stories that were equally false and wicked.*[111]

People were disgusted at the inability of the sheriff to control the situation and, as a consequence, decided to create their own police force. At the time, the only way this could be accomplished would be to incorporate the village into a city, and this was done March 28, 1854.[112]

Underground Railroad Stations Along the Post Road

The American Revolution was fought from 1775 to 1783 to free the colonies from the oppression of England. Although the war was won by America, it failed to end oppression for about 10 percent of the population, namely America's black slaves. The Civil War (1861–65) finally decided the question of slave freedom in the affirmative. The years between the two wars saw America's great expansion into the western territories, tremendous achievements in industrial growth, the rise of sectionalism and the movement toward abolition of slavery.

Many people in northern states probably think that slavery occurred only on southern plantations and farms. The truth is that slavery was prevalent in several northern states, in particular New Jersey and New York. Slaves were not emancipated in New York until 1827, forty-four years after the end of the Revolutionary War. The Hudson Valley in New York, with its great estates, needed cheap labor, and slavery very often filled that need. Almost every family who had substantial money and land also owned slaves. Some historians have even mentioned a couple of undocumented cases of free black families owning their own slaves.

The valley had more than its share of slaves, abolitionists and anti-abolitionists. In 1790, there were about twenty-one thousand slaves in New York State! Treatment of New York's slaves was probably milder than in southern states, but there were some extreme cases of cruelty. In the 1740s,

A freedom seeker begins a long journey.

a slave from Red Hook in Dutchess County who was convicted of arson was burned at the stake in Poughkeepsie along the Post Road. In another case, Gilbert Livingston (in Columbia County) "beat a slave severely to punish him for running away. The slave died out of 'doggedness.'"[113] New York City whites lived in fear after the slave rebellion of 1741 was exposed, and blacks died in fear during the reprisals of 1742. Slaves were auctioned off, and black families were broken up, just as in southern states.[114] Even the slave families who were treated "kindly" were often humiliated by such treatment as being segregated into the balconies at church services and having relatives buried in separate sections in cemeteries.

SEVERAL UNDERGROUND RAILROAD "TRACKS"

Our story will focus on the abolitionists and, in particular, the methods and places that were used to shepherd runaway slaves from the South to freedom in Canada. The network of people and places of safety was

called the Underground Railroad. "The Reverend John Rankin of Ripley, Ohio, wrote that the Underground Railroad was so called 'because they who took passage on it disappeared from public view as really as if they had gone into the ground.'"[115]

The Hudson Valley was one of the "railroad mainlines" and was the major link between New York City and Albany. From Albany, several "branch lines" led to freedom in Canada: one branch headed west to Utica/Syracuse/Rochester/Canada; another branch led north and east to Troy/New England/Canada; another branch led into the Adirondacks, where many fugitive slaves settled down to farming; and still another branch led north through the Lake George/Lake Champlain Valley directly to Canada. Probably no two fugitive slave trips were ever the same. A runaway family would be passed from station to station. Perhaps they would cross the Hudson River to the west side, or perhaps they would take a boat several miles north on the river. After the completion of the "real" Hudson Valley Railroad in 1850, the slave family might ride in a baggage car all the way from New York City to Albany and beyond in one night. However, the most usual and reliable route or "track" was straight up the Albany Post Road in the back of a wagon, the slaves hidden under blankets and other material.

There are very few facts about the Underground Railroad that can actually be confirmed because operation of the railroad was done in almost complete secrecy, and very little information was actually recorded. This story is based mostly on legend, and almost every town between New York and Albany has its legends. One fact is clear, however; the Underground Railroad helped about seventy-five thousand black slaves reach freedom in Canada.

FICTIONAL FAMILY

The population of African Americans was greatest in urban areas along the Post Road, namely New York City, Peekskill and Poughkeepsie. Also, most abolitionists and Underground Railroad "conductors" could be found in the same places. The major hiding places on the Underground Railroad were free black churches, free black homes and homes and meetinghouses of Quaker families. Conductors rarely used the same

station twice in a row, and there were numerous alternate tracks. We will follow a fictional runaway slave family from New York City to Albany, along and near the Post Road.

NEW YORK CITY

Our fictional family had arrived in New York City aboard a railroad freight car (and tugboat across the Hudson River) from Philadelphia. They were brought from the docks by coach to the home of Reverend Theodore Wright at the corner of West Broadway and White Street. During their second night in New York, they were moved to Wright's bookstore at 36 Lispenard Street (nine blocks west of the Post Road). The third night, they were shuffled a few doors down the street to "the Zion African Methodist Episcopal Church, the largest black congregation in the city,"[116] where they entered the underground through a trapdoor in the church floor.[117] Our family spent their fourth night in the great metropolis in the back room of Thomas Downing's oyster house restaurant at 5 Broad Street near Battery Park, at the beginning of the Post Road. On the fifth and sixth nights, they stayed with a white family for the first time since they had escaped from Maryland. Isaac T. Hopper, a Quaker, gave them shelter in the cellar of his home four blocks east of the Post Road at 110 Eldridge. After a week, it was finally deemed safe to move north of the city.

DOBBS FERRY AND PEEKSKILL

At eleven o'clock at night, a wagon with a load of empty milk cans passed near Hooper's home, slowed down and took on four passengers—our escaped slave family. A canvas was thrown over the little group as it made its way to Dobbs Ferry, Westchester County, and the home of another Quaker, Stephen Archer. Here they slept in a warm, comfortable back room of the giant Livingston mansion.[118] The runaways always slept during the day and traveled at night. The next night, they were sent, again by wagon, to Peekskill, Westchester County, where several friends of the abolition cause awaited. They were brought to the home of John

Livingston mansion.

Sands at 1112 Main Street, one block east of the Post Road. This home "had a secret stairway that led to a secret room."[119] They spent one night at the Sands home and on the second night were moved to the home of the wealthy abolitionist Henry Ward Beecher. For a couple hours, they were secreted in a fifty-foot-long tunnel at the lower part of Beecher's property until their ride arrived. Beecher provided a lot of money to the Underground Railroad to buy food and provide transportation to the black freedom seekers. Next stop: Baxtertown.[120]

FISHKILL AND BAXTERTOWN

After leaving Peekskill, our family inched slowly north on the map toward freedom in Canada. This stretch was a rough climb through the Hudson Highlands. As they approached the village of Fishkill, they were handed

off to their next contact, Joe Collis. "Joe was an underground station master. He peddled fish in Fishkill and blew his horn in certain rhythms known to the initiated, giving the numbers expected and the place of meeting the escaped runaways."[121] Baxtertown, a short distance northwest of the Post Road, was near Fishkill. It also was at the intersection of two Underground Railroad mainlines. One came from Peekskill through the Highlands, and the other came from Fishkill Landing on the Hudson River. Baxtertown was the largest settlement of all black families in Dutchess County. The rural community was large enough that it had its own AME Zion Church. It was a very safe and friendly place for the (former) slaves to rest and hide. Some even settled there permanently.

Our family stayed at Baxtertown a week while they regained their strength and health. One of their hosts told them a story about a single black man who had rested at his house the previous winter. The man had traveled another mainline track through New Jersey and Orange County, New York State, until he had come to Cornwall on the Hudson River. There, a conductor, Peter Roe, on a frigid night, drove him "in a sleigh over the ice of the Hudson River to Fishkill. A dangerous journey! There were holes and cracks in the ice, and the movement of the tides beneath it made its breakup a possibility."[122]

POUGHKEEPSIE

Next stop on the Post Road: Poughkeepsie.

By 1851, Poughkeepsie had grown to be a small city with three distinct black neighborhoods. "The black population was located: first, on the fringes of the central business district bounded by Washington and Market Streets; second, on 'Long Row' by the Almshouse; third, in the area of Catharine, Cottage, and Pine Streets."[123] Prominent abolitionist leaders in the black community included David Ruggles, Reverend Nathan Blount, Reverend Samuel R. Ward, Reverend James N. Mars, Uriah Brown, Ezekiel Pine and Peter Lee. Mutual aid societies and vigilance groups were centered mostly at the Catharine Street AME Zion Church, a few blocks east of the Post Road.[124] As at Baxtertown, the black population was so numerous that many runaway slaves felt that

it was safe to stay in Poughkeepsie instead of continuing on to Canada. There is recorded a very tragic story (with a happy ending) of a black runaway who tried to mingle with Poughkeepsie's free black community:

> *John A. Bolding was born about 1824 in South Carolina, a slave. He was a mulatto, almost white in color. About 1846 he escaped from his owner and in some way, now unknown, came north and settled at Poughkeepsie. He obtained work as a tailor in a shop on Main Street and early in 1851 married; his wife, a resident of Poughkeepsie, being also a mulatto.*
>
> *Some six months after John Bolding was married, a southern woman, staying in Poughkeepsie, reported his presence there to his owner, Robert C. Anderson of Columbia, South Carolina, and Mr. Anderson instituted in New York City proceedings to recover him. As Bolding was at work in the tailor's shop on August 25th, 1851, a United States Marshall, Henry F. Tallmadge, arrived at the door in a closed carriage, seized Bolding forcibly, placed him in the carriage, drove to the railroad and took his prisoner to New York. There, in the next few days, the case was tried before United States Commissioner Nelson and by his decision Bolding was returned to Mr. Anderson.*
>
> *Meanwhile the forcible seizure of the fugitive slave at Poughkeepsie by the United States Marshal, Mr. Tallmadge, had excited that northern village community to white heat and at once a popular subscription was opened for the purpose of buying the slave and giving him his freedom. A fund was started at Poughkeepsie and contributions ranged from fractions of a dollar to as much as fifty dollars.*[125]

Two weeks after Bolding had been abducted, he was a free man; 168 Poughkeepsie citizens had contributed $1,109 for his release. A notebook was kept with the name and amount of money that each person had contributed. Although most people on the list were not committed abolitionists, their sympathies toward slave freedom were completely evident. Some of the more noteworthy people on the list were industrialist George Innis; historian Benson J. Lossing; retailers P. Luckey, J. Luckey, Daniel W. Platt and Isaac Platt; and Vassar College founder Matthew Vassar Sr.[126]

Hyde Park

Our fictional runaway slave family could have stayed at any one of a number of safe houses in Poughkeepsie or even a couple of rumored Underground Railroad stations a little farther north in Hyde Park on the Post Road.

Rosedale, a beautiful and large house two miles north of Poughkeepsie, was a supposed stop. Of all the legendary but unconfirmed stops, perhaps Rosedale is the most intriguing. It was owned by the great-grandfather of President Franklin Delano Roosevelt, James Roosevelt. In the cellar of the mansion, there is a trapdoor that leads to a stairway and a small subbasement. This would have been a perfect place for runaways to hide.[127]

The historic Bergh Tavern[128] in Hyde Park is claimed to be another stop. A former owner of the restaurant, Edmond Fabbie, has said:

> *There was an underground tunnel, which still existed in the 1960s, but after the timber supports collapsed, the tunnel was filled in. It went from*

The Underground Railroad.

the southeast corner of the building, and up the hill to another house that was on the property. They would move the slaves through the tunnel, between the two houses, waiting for wagons outside to take them north to Canada. I spoke to a fella who grew up in the house, and he used to play in the tunnels. He said he had some things in his possession that he had found there, including some old coins.

About half a mile east of the Post Road in Hyde Park, before and during the Civil War, there was a hamlet of perhaps a couple of dozen ramshackle homes called the Guinea community.[129] The residents were mostly former slaves of the river estate families, such as the Pendletons, Bards and Stoutenburghs. Some residents may have been freed slaves from other localities, and some (temporary) residents may have been runaway slaves from the South. It would have been very easy for freedom-seeking slaves to mingle in with the black residents at Guinea. The most prominent member of the community was Primus Martin.

Rhinebeck

Farther north in Rhinebeck, there is a legend that a tunnel ran under Livingston Street from house to house a few yards east of the Post Road. Reverend Robert Scott, founder of the Baptist church on that street, was one of the more vocal abolitionists in the area. (It is interesting to note that if every rumored tunnel was used frequently, the escape to freedom would have been damp and dark, indeed.) Three miles more and they could have stayed for a rest or overnight at the Quaker meetinghouse, and even farther, they probably would have changed direction to hide out in Hudson, a city founded by and almost entirely populated by Quakers, three miles west of the Post Road.

Undoubtedly, there were also safe homes and barns in Claverack, Kinderhook, Schodack, Ghent and East Greenbush. The Albany area was crowded with abolitionists, and our slave family would have been home free on their way to Canada.

Samuel F.B. Morse

Painter, Inventor, Early Photographer and Political Agitator

A short distance south of the city of Poughkeepsie, where the old Post Road once traversed a sharp downhill past the Poughkeepsie Rural Cemetery, a fine old mansion sits majestically between U.S. Route 9 and the Hudson River. Surrounded by ancient locust trees, the mansion was once the home of Poughkeepsie's (and maybe America's) most famous person, Samuel F.B. Morse. He was not only the inventor of the telegraph and the Morse code, but he had at least three other callings as well: a career as a world-class painter, a career as one of the first American photographers and an unsuccessful career in politics. His contemporaries often called Morse the "American Leonardo" because of his varied talents and sometimes the "Lightning Man" because of the use of electricity in his telegraph invention.

Samuel Finley Breese Morse was born in 1791 at the Congregational parsonage at the foot of Breed's Hill battlefield in Charlestown, Massachusetts, the son of Reverend Dr. Jedidiah Morse. Jedidiah achieved notoriety in the Protestant community by authoring the first American geography textbook, but son Samuel sought fame by using different talents. His hope was to become the best painter in the world. While in England studying his chosen profession, he wrote home, "My ambition is to be among those who shall reveal the splendor of the fifteenth century; to rival the genius of a Raphael, a Michelangelo."[130]

EXTRAORDINARY PAINTER

He definitely had the talent to accomplish his goal, but his misfortune was that his classical style of historical painting was not popular with the American public in an age that glorified commercial invention, the pursuit of money and the painting of personal portraits for ego satisfaction. Money meant nothing to Morse; recognition meant everything. In 1822, at a time when his family really needed the money, Morse gave $500 (a lot back in those days) to the Yale University library purely on a whim. By 1836, while teaching part time at New York University, he was so poor that he was obliged to bring in meager groceries at night and do his own cooking because he couldn't afford the food that the university supplied to its students. His wife, Lucretia, had died in 1825, his three children were being raised by relatives and friends and he was truly living the life of a "starving artist."

There were a few of his paintings that made some people sit up and take notice. The problem was that there were never enough of those people to pull him out of poverty. Some of the more noteworthy works include *The Judgment of Jupiter*, *Congress Hall*, *Exhibition Gallery of the Louvre*, *Allegorical Landscape of New York University*, more than three hundred portraits—including those of Presidents James Monroe and John Adams, Colonel William Drayton, William Cullen Bryant, Judge Steven Mix Mitchell and Hannah Grant Mitchell—and perhaps his most famous painting, a portrait of Lafayette in old age at the time of his grand tour of the United States in 1825.

RELIGION AND POLITICS

There were some bright spots in Morse's painting career, such as in 1830 when he was sent to Europe to do commission work by some of the most influential men in New York City. Former mayor Philip Hone and Dr. David Hosack, as well as nine or ten others, had given him advances of more than $1,000, enough to live a year and a half in Europe. He traveled to England, Paris, Italy and Austria, all the time sketching and painting but also making notes in his journal about his

observations of Roman Catholic individuals, who seemed to surround him everywhere. On the Continent, he was a lonely Protestant in a land where Catholics were dominant. His disdain for the ceremonies of the Catholic Church steadily grew until it became outright hatred following an incident in Rome.

While watching a religious street procession of Catholic monks, he purposely did not remove his hat as a sign of disrespect. A soldier standing nearby knocked it from his head, and needless to say, Morse took the affront (of an affront) very badly. His shadow career as an anti-Catholic propagandist and political agitator had begun. In later years, his hatred of Catholics, immigrants and any person of color would develop into complete bigotry and old-age paranoia. It was the saddest aspect of the character of an otherwise brilliant man.

Upon his return to America, Morse quickly rushed into print two essays, "Foreign Conspiracy Against the Liberties of the United States" and "Imminent Dangers to the Free Institutions of the United States through Foreign Immigration."[131] It was his theory that if enough Catholics or other immigrants were let into the United States, European monarchs or the Pope would someday control the American government. "Morse called on all New York patriots to stand tall against the growing power of the Catholic hierarchy and the onrushing influx of the Irish."[132] He became a leader of the Nativist (aka "American" or "Know-Nothing") political party and ran for mayor of New York City twice (losing badly twice), in 1836 and 1841. Morse also developed an anti-black, proslavery attitude. During the Civil War, he was known as a "Copperhead" (a pro-South Northerner) and once said that if Abraham Lincoln was reelected in 1864, he would leave the country and never return. Of course, Morse never followed through on that statement when Lincoln was reelected.

QUITS PAINTING

The impoverished Samuel Morse became so discouraged that he gave up painting altogether in the mid-1830s. "At one point in later life Morse expressed the wish that, except for a few he valued as family documents,

his pictures might all be destroyed."[133] During the worst of the Morse family poverty and depression, however, he began to tinker with a new idea. It was an idea that by 1837 would finally bring him the fame that he desperately sought.

THE TELEGRAPH

Morse had struck on the concept of sending "intelligence" through wires using an electric current. The idea came to him during long conversations with other passengers on the ocean voyage home from Europe on board the now famous ship *Sully* in 1833. He would send numerically coded messages from one magnetic device to a similar receiving magnetic device, in other words "the telegraph." With an incredible symbolic act to finish his painting career, he used an old frame for stretching his canvas paintings to construct part of the first telegraph. Using theories that had been developed by Professor Joseph Henry (first secretary of the Smithsonian Institution), Morse built and improved several working models[134] until, in 1844, he demonstrated his invention to members of Congress when he sent the famous message from Washington to Baltimore: "What hath God wrought?"

When fame did come his way, Samuel Morse was absolutely unwilling to give even partial credit to others. Professor Henry had given valuable advice to Morse, "including the idea for the relays, which would renew and sustain faint signals over many miles of wire,"[135] and Henry had also contributed the ideas of "the electromagnet" and "the armature receiver."[136] Ezra Cornell (the founder of Cornell University) had developed the inexpensive method of stringing wire on poles instead of Morse's unworkable attempts at underground wires.[137] Stephen Vail had built a metal telegraph device instead of the clumsy wooden device that Morse had built. U.S. Representative Francis Smith had given a Congressional push to Morse's project. Alfred Vail (one of Morse's partners) had quite possibly worked out the details of the Morse code.[138] Even an unnamed former student of Morse's had loaned him fifty dollars to buy a new hat and pants so that he would look presentable at his 1844 Congressional demonstration. To Morse's credit, however, goes the fact

that he put all of the ideas, financial backers and divergent personalities together to finally make the telegraph a reality. He could more properly be called a great organizer than a great inventor.

"Father of American Photography"

In 1839, while on a tour of Europe seeking investors and contracts for his telegraph invention, Morse found himself in Paris at an opportune moment. He became interested in a new art form: photography. After the Frenchman Daguerre announced his discovery of the chemical process that would reproduce images on copper sheets, Morse met with the inventor and purchased a copy of Daguerre's apparatus. He returned to America and opened a studio under the glass skylights on the upper floor of New York University.[139]

Morse once described his early problems at the studio:

> *The greatest obstacle I had to encounter was in the quality of the plates. I obtained the common plated copper in coils at the hardware shops, which of course was very thinly coated with silver, and that impure.*

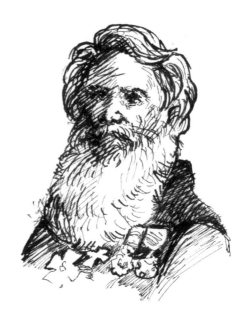

Samuel F.B. Morse.

Still I was enabled to verify the truth of Daguerre's revelations. The first experiment crowned with any success was a view of the Unitarian Church from the window on the staircase, from the third story of the New York City University. This, of course, was before the building of the N.Y. Hotel. It was in September 1839. The time, if I recollect, in which the plate was exposed to the action of light in the camera, was about fifteen minutes. The instruments, chemicals, &c., were strictly in accordance with the directions in Daguerre's first book.[140]

Morse also uncharacteristically took in students in a program to share his knowledge of photography. Two of his students brought the phenomenon of photography to popularity in later years. Albert Southworth in Philadelphia and Mathew Brady,[141] who opened a studio on the Post Road in Lower Manhattan, became famous. Brady's photos of Civil War leaders and battlefields (always taken after the actual battle so that the subjects of his photos, dead soldiers, remained still) are prominent in any history book of events of that time period.[142]

RETIRES AND MOVES TO THE POST ROAD

In 1847, while in his mid-fifties, Morse decided that he had enough money and fame to retire from active business with his new wife, Sarah Griswold, a young cousin half his age, who was deaf and very dependent on him. Purchasing an estate overlooking the Hudson River on the southern outskirts of Poughkeepsie, they would become landed gentry, like so many of Morse's customers for whom he had painted portraits. He had recently sold his telegraph patents and, for the first time in his life, felt financially comfortable. He chose the famous architect Alexander J. Davis to design a magnificent four-story Italian villa, complete with a latticework veranda from which he could watch traffic pass by on the Post Road. The dusty (or muddy, depending on the season) road was especially busy each autumn when wagonload after wagonload of freshly picked apples would be brought down from farms all over southern Dutchess County to the docks at Poughkeepsie for shipment to New York City and points beyond.

Samuel Morse (seated center, holding hat) with his family at Locust Grove, Poughkeepsie.

Not actually moving into their new estate, Locust Grove, until 1852, the Morses had to adjust to events that had occurred at Poughkeepsie since their purchase in 1847. The first event was highly personal to the Morses: the Hudson River Railroad had cut them off from the entire river frontage below their house. Perhaps the railroad was so new and interesting that Samuel and Sarah Morse were intrigued by the noise, smoke and tremendous speed of the trains to complain. No published mention of the railroad was ever made by Morse other than the fact that telegraph lines had been strung directly from his home in Poughkeepsie to New York City along the railroad.

The second event was the horrible anti-Irish riot that happened on a cold Saturday night in January 1850. The riot may actually have been welcome news to Morse because it would have fit right in with his personal nativism political philosophy. It may have also led him to believe that there were plenty of people in the Poughkeepsie area who supported

his anti-immigrant politics. He ran for the United States Congress (but lost) later in 1854 from his Dutchess County District.

Maybe the voters wouldn't vote for him, but he was always treated with respect, and during the twenty years living at Poughkeepsie, he was also treated as a hometown hero. Once, after returning from a trip to Europe in May 1858, he and Sarah were greeted at the Poughkeepsie train station by what seemed to be the entire population of the city. Carrying flags and banners, the huge cheering crowd formed a parade that "followed them in carriages and on foot through town, amid ringing bells, waving flags, and schoolchildren let out for the day." As the procession wound up the Post Road and "reached the flower-wreathed gateways of Locust Grove, a band struck up 'Sweet Home' and 'Auld Lang Syne.'"[143]

Locust Grove was the happy summer home of Samuel Morse and his second family until his death in New York City on April 2, 1872. "Around the world the telegraph flashed the news that its father was dead."[144]

The Smith Brothers of Poughkeepsie

Their Famous Cough Drops (and Beards)

The governmental and business center of Poughkeepsie is a short two-block segment of Market Street, the former Albany Post Road. It is also the historical heart of the city. Here is located the Dutchess County Courthouse, the successor to another courthouse on the west side of Market Street that stood on the same spot. New York State delegates ratified the United States Constitution on July 26, 1788, at the earlier courthouse, becoming the eleventh of the original thirteen colonies to do so. For a month before the ratification, the constitution had been debated—leaders John Jay, Robert R. Livingston and Alexander Hamilton for, and leaders Melancton Smith, John Lansing, William Harper, Robert Yates and Governor George Clinton against.[145] Ratification became possible when some of the nay voters changed their position after being promised that a citizens' list of rights would be added to the constitution. "With Clinton presiding, the New York convention ratified the Constitution with recommendatory amendments, with a prefatory statement of what rights New Yorkers believed were reserved to the people."[146] The little courthouse on the Post Road in Poughkeepsie can justly be called the birthplace of the United States Constitution's Bill of Rights.

In the later 1800s and early 1900s, history of a different (and certainly much less important) sort was made in the same block. Today, as a person travels north, just before he reaches Alex's Restaurant[147] at the

Smith Brothers' famous packaging, artist unknown.

corner of Market and Main Streets, there is a vacant building on the east side of the street. Up on the fourth floor, visible on the north side of the brick building, is a faded sign ("Smith Brothers Restaurant"). One hundred years ago, it was the most popular restaurant in town and was the birthplace of a nationwide business that became famous for the innovative packaging of its product.

The story begins in 1847 when a Scotland native, James Smith (1800–1866), immigrated to Poughkeepsie by way of St. Armand, Quebec. With him was his family, which included his young sons William Wallace Smith I (1830–1913) and Andrew Smith (1836–1894). The Smith family worked hard at menial tasks and built up a small nest egg by saving every penny, like any good Scot would. They were able to rent a building at 13 Market Street and became well known in Poughkeepsie for their home-style cooking. Because of their Scotch notoriety, the Smiths were able to avoid becoming victims of the terrible anti-immigrant riot that occurred on a freezing cold night in January 1850. During the riot, a mob pulled only Irish immigrants from their homes and dragged many of them naked into the streets.

By 1852, things had settled down when an even more momentous occasion happened at the Smith restaurant. The incident has become a legend of American business folklore. A boarder in the Smith home, peddler Sly Hawkins (nationality and reputation unknown), owed some

Smith Brothers Restaurant (at left) on the Albany Post Road.

money to the Smiths and paid his bill with a recipe for some cough drops. Perhaps father James Smith thought the recipe was better than getting nothing from Hawkins, or perhaps Smith really liked the taste. At first he mixed a batch in his home kitchen and was soon cooking batches of the "cough candy" in the furnace in the cellar of the restaurant on Market Street. James soon had his sons peddling samples, and then the real thing, to stagecoach passengers, who refreshed themselves at the Forbus Hotel[148] directly across the Albany Post Road from the restaurant. The passengers would take one, two or more of the packages with them, and the fame of the cough drops was spread by word of mouth from New York to Albany. The James Smith & Sons Compound was advertised in the local newspaper "for the Cure of Coughs, Colds, Hoarseness, Sore Throat, Whooping Cough, Asthma, etc. etc." (unproven claims that would have made peddler and possible snake-oil salesman Sly Hawkins proud).

Black Market for Black Cough Drops

The popularity of the cough drops spread far beyond the Hudson Valley, and the Smith family was soon cooking six tons per day of the candy at a new factory on Church Street around the corner of the Post Road. At a time before automated packaging machines were common, the Smiths filled their ever-increasing orders by loading up five-gallon milk cans with cough drops and then distributing the cans by horse and wagon to about thirty poor families along Church Street and the Post Road. In the morning, each tiny package, which contained exactly sixteen drops, would be picked up by the same horse and wagon. However, according to a local legend, a large number of the cough drops (as much as 50 percent) found their way into the black market. "One drop for the company and one drop for me."[149]

Imitators

Brothers William and Andrew took over the business in 1866 when father James Smith died. Sales were skyrocketing as their product became popular all over the country. With success, however, came competition and imitation. "Schmidt Brothers," "Schmid Brothers," "Original Smith Brothers," "Improved Smith Brothers" and even "Smith Sisters" tried to take advantage of the popularity of the true Smith Brothers Cough Drops. Not until 1877 was the Poughkeepsie product protected by a registered trademark.

A Happy Mistake

Probably by a miraculous and fortuitous mistake, the Smith brothers stumbled onto one of the first American advertising gimmicks. The registered cough drop package had a woodcut image of the heavily bearded brothers—William on the left, with "Trade" under his portrait, and Andrew on the right, with "Mark" under his. It struck the fancy of the American public, and the brothers, for the rest of their lives, were kidded

about being Trade and Mark. The names seemed to fit. Trade (William) was the better businessman and ran the "trade" by micromanaging everything. He never drank alcohol and even refused to serve ginger ale in his Post Road restaurant because it seemed to him that it sounded too much like the alcoholic ale. The more easygoing Mark (Andrew) would take a drink every now and then and could be hit up by his friends for any risky loan—he was an easy "mark."

The cough drops company's best salesmen were its owners. Once, William had the opportunity to meet President Taft at a YMCA reception at the White House. He kept working his way to the back of the line because he assumed that the last person in line would have a better chance to have a longer conversation with the president. Taft did indeed talk with him longer than the others, one reason being that when Smith shook his hand he left a box of cough drops in it.

Another time, one of the brothers was headed to Albany on the train. While collecting tickets, the conductor noticed an elderly man, in a panic, stand up and go through his pockets. Approaching the old guy, the conductor tried to calm him by saying that he wouldn't toss him off the train if he had no ticket. Smith replied, "Here's the ticket. I was looking for a box of my cough drops to give to you."[150]

Cough Drops Go to War

Though not exactly a war industry, Smith Brothers Cough Drops increased production during World War II by 25 percent. All of that increase (millions of cough drops) went to the Quartermaster Department of the army for shipment overseas. If the figure of millions can be sifted down to individual cases, perhaps a few wet and solitary soldiers in foxholes were saved from snipers' bullets when their coughs were suppressed by the Smith brothers.

After two years of experimenting, the company had begun to use liquid sugar to replace granulated sugar in the manufacture of the drops. This proved to be the lucky step that allowed increased production and subsequent sales to the military.[151]

END OF AN ERA

Smith Brothers Cough Drops had an unconventional beginning but had a very typical ending. By 1919, Smith Brothers, Inc., was producing a total of one million packages of cough drops a day at its two factories—one in Poughkeepsie and one in Michigan City, Indiana. Members of the fourth generation of the Smith family were millionaires, and things were looking good. New products were introduced—Menthol Cough Drops in 1922 and Triple Action Cough Syrup in 1927. By 1963, however, the management of Smith Brothers decided to make a huge windfall pile of cash and sold out to pharmaceutical giant Warner-Lambert. Nine years later, cough drops apparently weren't making as much profit as designer drugs, and the last cough drop was made in Poughkeepsie.[152]

Gypsies on the Post Road

P robably the most interesting people to be found along the Post Road were the gypsies. Because the gypsy has mostly disappeared from the American landscape, the story now has to be gleaned from a few meager sources. Very few nonfiction stories have been written about gypsies because of their secretive lifestyle. It was almost impossible to interview a gypsy. A reporter for *Harper's Weekly* in 1882 wrote the following story based entirely on his observations and impressions:

> *One of the most interesting sights in New York at present is the gypsy encampment on the block bounded by Broadway, Seventh Avenue, and Fifty-eighth and Fifty-ninth Streets* [a few blocks west of the Post Road], *where anyone who desires to do so may make the acquaintance of a genuine band of this singular race. Most of them are English, and the band numbers about fifty souls. They were brought to this city to take part in the gypsy camp scene in the play of* Romany Rye, *at Booth's Theatre, but their days are spent in the usual pursuits of their race. The men are great horse-dealers, and the women ply the vocation of fortune telling with great assiduity and success.*
>
> *The lot on which the gypsies have squatted was a vacant one. It was fenced in for their accommodation, and as soon as they arrived they pitched their tents, and settled down to their occupations as if they*

Gypsies at Claverack Creek.

had already lived there. But all lands and places are home to a gypsy. A measure of wildness in the ground adds to the picturesqueness of the scene. The tents and wagons stand against a back-ground of broken rocks, and looking into the enclosure one would scarcely realize that he was standing in the center of a great city of the New World. These gypsies will remain several months in New York, and their camp will be an interesting place for the student of character to visit.

The heyday of the American gypsies was the last half of the nineteenth century. This period coincided with the flood of European immigrants into America, starting in the 1830s and 1840s and ending about the time of World War I. A traveler on the Post Road, if he made it all the way from New York City to Albany, would probably pass three or four or five gypsy camps along the way.

One popular camp was located just north of New York City in once rural Yonkers. It lay a few blocks east of the Post Road in a wooded meadow called "Nepperhan."[153] Cromwell Childe reported his impressions in a full two-page story in the *New York Times* in 1889.

Like the reporter mentioned previously, he actually conducted very few interviews and mostly reported what he saw and heard. Excerpts from the story follow.

FORTUNETELLER

Into the shadow of her tent, she drew the inquisitive man…Boxes set around the tent's edge inside displayed on corners of white cloth toilet articles, dishes and glassware, provisions, picturesquely heaped together. A baby in a red dress in a high "baby cart," slept peacefully, a length of mosquito netting thrown over him. At one side was a mass of bedding and pillows, the brilliant red of their covering conspicuous through their adornment of coarse linen lace.

The surroundings, the quaintness of tone in which the seeress delivers her prophecies, are what give a gypsy fortune its charm. The phrases of this young gypsy matron slipped somewhat too glibly over the tongue; they were almost too parrot-like. It was the same old fortune people like so much to hear—of speedy prosperity, of a certain date that must be guarded against, of four wishes, of men of whom a care must be had. Only odd little sayings marked its delivery, curious movements. A phrase that was uttered a dozen times or more ran something like this: "Don't be insulted, don't be offended at what the gypsy says, mustn't mind my asking you."

Quaint foreign mannerisms accompanied every uttered word. The climax was reached when it came to the incantation for the fulfillment of the wishes. Into the palm of the hand she held—the left hand—she directed that a few coins be poured. Still holding this hand, she muttered, pointing to the north, south, east, and west of the palm, gypsy word after gypsy word. Curious, unusual, the brain of the man who heard them retains no distinct memory of what they were. He recalls only a softly modulated jargon, a survival, doubtless, of some ancient phrases of gypsy rite.

MEAL TIME

Rather in front of each tent than within it was the "home," for here on the bare ground stood the cooking stove of each household, a tiny affair,

fit to be packed away readily into wagons, its chimney frequently steadied by a pole. In the face of this modern, genuinely American improvement of gypsydom, no stove lacking even its little oven, the gypsy pot hung over a gypsy blaze had, of course, vanished.

By the side of these stoves each household washed its dishes, the matrons squatting by the tent flaps. When dishwashing time came, each husband and father…would arouse themselves from their postures of ease, and sally forth with the water pail, sometimes with even two pails. The food for each and every tented ménage was drawn as needed from nooks and crannies under the canvas, from behind boxes, from—it cannot be told where. Right merrily, heedless of what might come tomorrow, were these gypsies living, traditionally, as thorough-paced gypsies should. Though the sun beat upon the gray-white walls of that camp, there was not the sign of an ice chest or a solitary bit of ice within its bounds.

The Gypsy "King"

Advisedly he has this name, and in absolute monarchy is that of old Plato Bucklin. Eleven years—and some of "subjects" say fourteen—he has been roaming over the country, leading the real old-time gypsy life. As time has gone on, daughter following daughter has married, some to the "hired men," others to outsiders, until four out of the seven have been "united" by gypsy rites, all, however, remaining in the clan, inducing such of their husbands as came from outside to become gypsies in fact.

Nearly forty, all told, children in arms at the one end, Father Plato, the "old man," and "Aunt Betsy," his wife, at the other, now make up this band of wanderers that started in England years ago, sprung from gypsy stock, and has journeyed all through the East, from Maine to Georgia, inland as far as Ohio. Save for the sons-in-law, who have become the best, (i.e., the most indolent, of gypsies), and the "hired men," all are descendants of the silent old man who knows so well how to rule.

Women Do the Work

The camp's…employments are the horse trading, the only occupation of the men, besides caring casually for the wagons, and (for the women)

housekeeping, washing, fortune telling, lacemaking, basketmaking, and the hieing forth to sell baskets and lace along the roadside and in the suburbs of the nearest city. A penny here and a penny there, with a great family community working in genuine co-operation, means in all a snug little sum continually, providing with ease "all the comforts of (gypsy) home."

The women in gypsy land, if this camp may be taken as a fair example—and undoubtedly it may—have no easy days. Any way it is looked at theirs is a life of toil. It is not hard, unremitting toil; there are lightsome pleasures scattered through every day, but the gypsy woman must work. She is the mainspring of the camp's fortunes. It is she that attracts visitors, that sells the gypsy wares, that cooks, washes, and irons. Like their fathers, the boys stroll aimlessly about, but the little girls from their earliest years must fetch and tend, mind the babies, and become generally useful from a gypsy point of view.

Horse Trading

Horse trading is not an exhausting task, as the farmers are generally only too willing to "swap," with a consideration now, and for something to boot then, as the case may be. The gypsies, whatever else any one may say of them, are shrewd traders, and the bargains they make are invariably excellent ones—for themselves.

Money comes in as the result of…horse trading, and the stock of horses, thirty to forty being the average number carried, is kept on the same plane. At times a burly farmer or some crabbed country resident will come back to the camp, bitterly inveighing against the horse that has passed from gypsy hands into his own. It is then the gypsy's powers of cajolement are seen at their best. Eventually the farmer is sent away perfectly satisfied, or at least grumblingly silent, talked to a standstill by his gypsy friend, perhaps allowed to replace the horse he has taken a dislike to by another—probably a worse one—on a deal even more unfavorable to himself. Farmers and others do not usually come back after trading with gypsy folks, however, for he who trades with a gypsy… knows beforehand the chances he must run.

Beautiful Daughters

The younger daughters—and the statement is made veraciously, without a word of exaggeration—were such Southern beauties that it was hard to imagine them as English girls that they really were. Gypsydom seems to have no country; the types, whenever one meets them, are unvaried. These girls had the rich, full olive of Europe's south, a cast of feature that markedly un-British, that tended mightily toward the Hungarian. And their array was gorgeous. First seen as they were starting out in two wagon loads, laden down with baskets and lace to sell—the baskets at 25 cents apiece, the linen lace at 50 cents a yard, they presented brilliant spectacles. Enormous red hats, flowered in red, sat on their black hair, their waists were of the gayest red cotton, made with many a furbelow, huge of sleeve, flamboyant, altogether stunning. They would have "carried the act" on any variety stage here, surprising figures against the green of the camps. A spectacle of drama on the dusty road, they dazed the eyes and bewildered the senses.

It was these gorgeously arrayed daughters that [were] sent out to scour town and country by day, to advertise the near-byness of [the] camp. No better avant couriers could have been selected. These were the brilliant butterflies of gypsydom, animated posters of the "old man's" encampment. One could imagine how in country and in town they wheedled and cajoled, how quarters and half dollars were drawn from the pockets of yokel and town boy, country maid, and town matron. The red about them was dazzling and fairly dramatic.

Colorful Gypsy Wagons

All the colors of the rainbow adorned the gypsy wagons. If the gypsy daughters were gay they were perforce, compelled to take second place to these. A circus chariot is hardly a circumstance to a genuine gypsy coach in commission…Certainly with its panels, the pictures on its sides, the narrow strips of its interior each a different color, the cost cannot be in any way light nor the bills moderate.

A gypsy wagon is a second home of the tribe. Each holds not only the household goods of each tented family, but provides sleeping

accommodation. They are close quarters, but comfortable. The back of each wagon is a bed, the front end a sofa, dressing table, parlor combined. Pillows, mats, dry goods, more things than can well be imagined, crowd this front end. Like the exterior of the wagon itself, the inner fittings are of barbaric colors, not a tint or a tone of the spectrum or its graduations being omitted. The result is an indescribable wonder, a hodge-podge of all that is curious, a combination unique and suggesting nothing, reminding of nothing besides itself.[154]

Several popular camps for the gypsy migrants were situated in the desolate section of the Post Road north of Peekskill. Other camps could be found in Wappingers, south of Hyde Park, south of Rhinebeck and in Red Hook, Claverack, Kinderhook and Greenbush. Some older Hyde Park residents can remember that gypsies had a camp at the top of Gay's Hill at the southeast corner of the Post Road and West Dorsey Lane as late as the 1930s and 1940s. Long after the days of the colorful gypsy wagons and plenty of open space to graze the horses, automobiles were then the mode of transportation. Young Mary Edgar said, "When they came in their caravans along the Post Road while [I] was walking along it, [I] would jump over the stone wall lining the road and walk through the woods even if it took [me] a mile out of [my] way."[155] Somebody else in the southern part of town would spot the gypsies heading north and telephone to the merchants in the main village to watch out. The wagons and open space had changed, but prejudice had not.

Gypsies appear in memories of Red Hook (a village in northern Dutchess County) residents even into the 1950s. A story is told how John Colburn, a local gas station operator (on the Post Road, just south of the village), allowed some gypsies to park their travel trailers in the brush lot behind his buildings. The gypsies were a hardworking lot and stayed all summer. They always paid for everything they needed, which, for some strange reason, included a lot of gas from his gas station.

The gypsies were popular with the nearby farmers. The gypsy men painted many of the area's barn roofs. They would swarm around the barn in a great team and have the roof painted before half a day had passed. Then they would attack another barn.

Arnold Colburn, John Colburn's son, told the following story to the Red Hook Historical Society:

> As quickly as the gypsies appeared, one day they were gone. When the fall rains came, so did the farmers whose barn roofs the gypsies had painted with aluminum paint. The farmers were looking for them because the paint was washing off with the rain. It seems that gasoline was cheaper than paint, and when they mixed it 5 to 1 with gas it covered real well and looked good until the first rain came and it began to wash off. The farmers were back to square one, less the cash they paid. The gypsies were never to be seen again, but my father had a very successful summer!

It was always thought that gypsies were an impoverished class of people and that this is why they resorted to fortunetelling or nefarious acts to feed themselves. Once, however, a story appeared in the *New York Times* that disputed that theory:

> Four families of gypsies, who arrived Tuesday night from Buenos Ayres on the steamer, Coleridge, were taken to Ellis Island yesterday, and their native instincts led them immediately to the roof garden, which they made their camping ground. When their time for examination came they were told that if they could show money sufficient to carry them to their destination they would be permitted to land, whereupon each member of the party went down into his or her cloths for a combined total, which the astonished immigration officials figured out to be nearly $10,000.[156]

At other times, because different people assumed that gypsies carried large sums of cash and didn't trust banks, these nomads of the highway became victims themselves when they were attacked by gangs of thieves. However, because the gypsies often traveled in family groups of forty or more, these attacks usually were rare.

Gypsy customs, habits and traditions were often amusing to the average nongypsy. The *New York Times* related this story about an incident that happened near the Post Road across the river from Albany: "Thomas Stanley, a gypsy, is in the Greenbush lock-up for having sold his wife to his cousin, Richard Stanley, in West Troy recently, for $1. The wife

cheerfully acquiesced in the transaction. An agreement was signed by all the parties."[157] The sale wasn't as unusual as one might think. In the few semifictional accounts of gypsy life, there are several incidents mentioned of buying and selling wives.

The people along the Post Road, and America as a whole, have lost a colorful, fascinating segment of society, probably forever.

Young FDR and the Gilded Age at Hyde Park

The Gilded Age in America was a period in our history that began upon the close of the Civil War in 1865 and ended about with the adoption by Congress of the income tax in 1913. Immediately after the Civil War, northern industries had modernized, northern transportation had expanded and many northern merchant families had become extremely rich. Without an income tax, a man could keep his wealth and keep his money sources secret. As long as a rich man obeyed the law and managed his business wisely, his fortune was secure.

"MILLIONAIRES' ROW"

About eighty of these wealthy families built estates along the Post Road north of New York City. The area was the world's greatest concentration of wealth and was called by many people "Millionaires' Row." The Post Road offered relatively comfortable transportation to and from New York City, and the Hudson River offered fantastic views and a convenient place to dock the omnipresent luxury yacht. Tarrytown, in Westchester County, was home to the wealthy Rockefeller and Jay Gould families, as well as the literary giant Washington Irving.

Seven-year-old Franklin Delano Roosevelt (right) with friend Edmund Rogers in 1889.

Farther up the Post Road, Hyde Park, a small hamlet of six hundred people in Dutchess County, was dominated by three adjoining estates. The three belonged to Frederick W. Vanderbilt (famous for his wealth), Colonel Archibald Rogers (not famous at all) and James Roosevelt (father of President Franklin Delano Roosevelt). The Rogers and Vanderbilt estates employed sixty to seventy-five workers each, and the Roosevelt estate employed somewhat fewer. It is fair to say that the three estates, in one way or another, supported almost everybody in the hamlet.

How wealthy were the three families? The Vanderbilt mansion,[158] which was built between 1895 and 1899, cost $2.25 million. Vanderbilt was on the board of directors of twenty-two railroads and various other corporations. When he died in 1938 (during the Great Depression), his estate was worth $77 million. The Rogers mansion cost a more modest $350,000 in 1890. Anne Rogers, Archibald Rogers's wife, made $1,000

per day on interest alone from her family fortune. Her brother, Robert Coleman, was the leader of a family in Lebanon, Pennsylvania, who had made a tremendous amount of money selling armaments to the Union army during the Civil War. The Coleman family fortune in 1889 was estimated at $30 million. The Roosevelts' money was "old" family money (some of their ancestors were Dutch colonists) and was mostly tied up in their property. The Roosevelts intermarried with other rich Hudson Valley families, and it was harder to get a dollar figure on their net worth. It was certainly a lot less than the Vanderbilts or Rogerses. During the Gilded Age, a worker on one of the Hyde Park estates earned an average of $1 per day. It has been estimated that 90 percent of America's wealth in 1890 was in the hands of 10 percent of the population.

HAVES AND HAVE-NOTS

Some of the sons and daughters of the Hyde Park estate workers are still alive. Surprisingly, most of them say that there was little resentment felt by the have-not workers toward the estate owners. It was just considered the natural order of things. While the wealthy families rode up and down on the Post Road in their fancy carriages and new automobiles, their workers would pedal through town on their bicycles or simply walk. The estate owners paid wages and benefits (sometimes room and board) at an average rate, or maybe better than the rest of the country. Other benefits included what would be called a health plan today. When a worker or somebody in the worker's family became sick, the estate owner would make sure, at the very least, that a doctor would pay a house call. Mrs. Vanderbilt was even known to send people from her estate who suffered from tuberculosis to Saranac Lake for recovery. The estate owners definitely had a paternalistic attitude toward the workers. Instead of simply giving a Christmas bonus to her workers, "Mrs. Vanderbilt, on Christmas Day, would drive down the Albany Post Road and through the village in a sleigh loaded with gifts that she handed out to the children she met."[159] Rocky Andros, a lifelong Hyde Park resident, remembered as a boy that Mrs. Vanderbilt would give each child a brand-new one-dollar bill if the child would call her "Madam."[160]

Springwood, FDR's home.

Before the Town of Hyde Park had a recreation department, the Rogers estate (Crumwold) was used as the town's first park: "On Sunday afternoons, Crumwold employees were encouraged to invite their families to picnic, use the bowling alley, or enjoy the grounds by walking and visiting the rose garden and greenhouse. Once a week, Mrs. Rogers arranged for the staff to take one of the Crumwold wagons down the Albany Post Road to Poughkeepsie for the day to do what they wanted."[161]

Some Rivalry and Some Snobbery

It would be wrong to group the three families together. Each had its likes and dislikes, and there was always some rivalry concerning money and social status:

Sara [Roosevelt] *had received a cordial note from Mrs. Frederick Vanderbilt. "She has invited us to dinner," Sara said. "Sally," James said, "we cannot accept." "But she's a lovely woman, and I thought*

119

you liked Mr. Vanderbilt." That was true, James allowed, he had served on boards with Vanderbilt and did like him. "But if we accept we shall have to have them at our house." Breaking bread with the new-rich Vanderbilts was unthinkable to the squire of Springwood [James Roosevelt].[162]

None of the estate owners sought local public office during the Gilded Age, except one time in 1871 when James Roosevelt was elected town supervisor. He also served on the school board for some time. His son, Franklin Delano Roosevelt, never won an election in Hyde Park. He paid the price for his parents' attitude of superiority. As a child, FDR "wasn't allowed to mingle with the Hyde Park children, whose parents worked on the great Hudson River estates. The village children were not the 'right sort,' his mother said. He would go up the Post Road into town for haircuts with his governess, but he was told not to speak to anyone."[163]

Unlike his wife, Louise, Frederick W. Vanderbilt didn't like the local kids and avoided them like the plague. The same Rocky Andros who received a brand-new one-dollar bill from Mrs. Vanderbilt got a different

Louise Vanderbilt.

Frederick Vanderbilt.

(and more snobbish) reaction from Mr. Vanderbilt: "When we were small, we'd be wandering all over the estate, you know. And if we would be walking up to the road there, and Mr. Vanderbilt would see us, he would hide behind a tree and get out of sight. Of course, we'd see him hiding behind a tree, but we'd just continue on. But he didn't want to talk to us at all."[164]

The rivalry was still there but probably more friendly when the three owners apparently decided to do something about the decaying milestones along the Albany Post Road in front of their estates. Each repaired his respective milestone with stone and masonry protection. James Roosevelt's son, FDR, kept an interest in milestone 86, the "Roosevelt milestone." When he was governor of New York State, he championed the protection of the milestones and the preservation of the giant sycamore trees that still line the Albany Post Road in front of his former estate.

What was life like on the great estates? We are lucky that one of the estates belonged to Franklin Roosevelt's father. More information is available about President Franklin Delano Roosevelt than almost anybody else in the world. FDR was tutored next door at the Rogers estate, so we even know something about that place. At the Rogers estate,

[p]rivileged children went on riding expeditions with the Colonel or the Rogers' tutor, they came there for dancing school. On these exciting winter afternoons the floor was cleared of furniture, the stuffed mountain goats and wildcats were pushed against the walls of the huge entrance hall, and the rugs were rolled up. Then the deer heads and great bear skins looked down from the dark, paneled walls, while the mothers, nurses, and governesses looked on, from the chairs along the walls, at the children's efforts to learn to dance. The neighboring children came by sleigh down the Albany Post Road.[165]

The employees' children didn't attend the Crumwold dance classes and went to school in the hamlet at a regular school on the corner of the Albany Post Road and Albertson Street.

Frederick Vanderbilt kept more to himself, so less is known about his personal life. He and his wife, Louise, had no children. They were the wealthiest couple in Hyde Park, but they lived modestly by Vanderbilt standards. While other Vanderbilts owned several ostentatious Gothic mansions, yachts and Rolls-Royces, Frederick preferred the more "academic" style of mansion[166] and was driven around in an automobile of less value than a Rolls-Royce. Although twenty Hyde Park servant families could probably have lived happily together in the Vanderbilt mansion, it was considered small by the other Vanderbilts. The nieces and nephews referred to it as "Uncle Freddie's and Aunt Lulu's cottage on the Hudson."

LEISURE TIME WHEN YOU ARE RICH

Either on the estates or off, Hyde Park must have been a unique and wonderful place to live during the Gilded Age. The Hyde Park mansions were a place of employment for the workers and a place of leisure for the owners. Although each estate owner had a "home office" for managing his mountain of money, most of his time was spent hosting friends or pursuing sports or entertainment. In 1900, joy riding with an automobile was a new fad when Frederick W. Vanderbilt received a visit from W.K. Vanderbilt Jr. In an episode that quite possibly was an inspiration for F.

Scott Fitzgerald's, *The Great Gatsby*, the September 22, 1900 *New York Times* reported the following story and titled it "Mr. Vanderbilt on a Flier?":

> *A white automobile of the French type, said to be the property of W.K. Vanderbilt, Jr., came up to Poughkeepsie from New York to-day, in the fast time of 3 hours and 59 minutes.*
>
> *It was reported that Mr. Vanderbilt was running the vehicle, but this could not be confirmed. When the vehicle was started off for Albany it was sent through Market Street and around the turn from Main Street into the old Post Road at a dizzy rate of speed. In turning a sharp corner the vehicle slipped, and it needed clever management of the levers to avoid an accident.*
>
> *After the auto-car had gone north two or three runaways were heard of, but nobody was seriously hurt. W.H. Van Keuren lost control of his horse and was thrown against a fence.*

W.K. Vanderbilt Jr. later became one of America's best race-car drivers. Apparently, his wealthy friends also liked racing. On December 17, 1912, the *New York Times'* front page had a story titled "Astor in Risky Auto Race":

> *It became known to-day that Vincent Astor, driving a racing car, and Frank Casey, chauffeur for Garrett Kip of Rhinebeck, had a narrow escape from death while racing on the Post Road, between Rhinebeck and Red Hook, yesterday afternoon.*
>
> *Casey, whose machine plunged out of the highway when he lost control of it, was hurled many feet through the air, but escaped with a few bruises and a severe shaking. The Kip car, which he was driving, was wrecked.*
>
> *Casey had long wanted to race his employer's car against Astor's new racer, which came up from New York last Summer. Yesterday the opportunity came. He was running from Rhinebeck to Red Hook when Vincent Astor overtook him. Immediately Casey turned on the power, and his machine shot ahead. Astor accepted the challenge for a race, and the two big cars sped over the level stretch of road at a sixty-five-mile clip.*

Mrs. Rogers with chauffer Percy Horrocks enter the Post Road.

Opposite the Frederick Martin estate Casey lost control of his car. The machine swerved in the roadway and plunged toward the Astor car. Astor quickly turned aside and so avoided a crash. The Kip car raced out of the highway and headed for the lawn of the Martin place. Nearly 300 feet away it crashed into a tree, and Casey was thrown out, landing on the soft earth many feet away.

Vincent Astor took Casey to his home, and the wrecked car was towed to a Rhinebeck garage.

Not many average folk had automobiles back then. Only the wealthy people had the money to buy them and the free time to race them. Perhaps they had disdain for the lower classes. Officials in Poughkeepsie thought that they had discovered a way to slow down the rich playboys and maybe solve the town's budgetary problems at the same time. They set up the first speed trap on the Post Road. Again the *New York Times* reported on September 30, 1906, in a story titled "Trap for Auto Parties. Old Post Road at Poughkeepsie No Place for Scorchers":

Residents on the old Post Road, exasperated by the speeding of automobile parties en route to New York from the Berkshire Hills and points up the State, have laid out a measured course south of Poughkeepsie to trap

unwary drivers. The course was manned to-day with Deputy Sheriffs, and two Justices of the Peace held court in a near-by barn.

Electrical buzzers and stop watches enabled the watching deputies to gauge the speed of passing automobiles to the fifth of a second. Those who exceeded the legal limit were asked to stop. One man who attempted to shoot by the deputies was halted with a shotgun.

S.B. Hoffman of Fifty-eighth Street, New York, who was returning to New York from Lenox, Mass., was caught exceeding the speed limit. He was hauled before Justice John Mack and fined $25, which he paid. The town officials expect to pay the entire town expenses of $2,500 a year out of fines imposed on automobile speeders. Scores pass over the old Post Road every day.

Sports for the Rich

Probably the most prestigious international sport at the time was racing yachts. In 1892, Frederick W. Vanderbilt and Colonel Rogers organized a team, or "syndicate," to defend the America's Cup. Other members of the team were also part of high society: W.K. Vanderbilt, J. Pierpont

Colonia, built in 1893
for Archibald Rogers.

Morgan, F. Augustus Schermerhorn and John E. Brooks. Most of the team members only contributed money to build the eighty-five-foot keel yacht *Colonia*, but it is thought that Colonel Rogers was actually a member of the forty-man crew. The steel-hulled yacht proved to be too heavy and too slow, so it was replaced by another yacht, the *Vigilant*. Other yachts owned by Rogers were the *Bedouin* and the *Wasp*.[167] Frederick W. Vanderbilt, at various times, owned the *Conqueror, Warrior, Vedette I, Vedette II* and *Rainbow*. In 1934, the *Rainbow* defended the America's Cup successfully at races in Newport, Rhode Island. The Roosevelt yacht was the *Half Moon*.[168]

In the winter, ice yachting was the popular sport for the Hyde Park gentry. Again the leader of the three estate owners was Colonel Rogers. He seemed to be the most adventurous and sporty of the three (James Roosevelt died in 1900 at the age of seventy-two). Ice yachting was very dangerous and required considerable strength and endurance. The "yacht" resembled two large ice skates with a sail. The pilot laid on a board between the skates and steered the yacht with ropes. Sometimes, if there was room enough and nerve enough, a passenger might join the pilot. The yachts could reach speeds approaching one hundred miles per hour, and sometimes they would even

> race the *"Empire State Express"* [a railroad train on the East shore of the Hudson] *and invariably, the ice yacht would be the winner, to the delight of the train passengers. It was classified among the hazardous sports. A Vassar girl bounced and slid 125 feet before she splashed into a waterhole. She was game enough to continue the hazardous voyage. Collisions simply wrecked the yachts, and scattered the teams like ashes. Archibald Rogers managed to get a line round his wife before she sank beneath the ice, when the strong stream threatened to swallow her as she clung to the breaking barrier, half dead with shock and the chill. Shelter was the hospitable Vassar Brewery in Poughkeepsie, and the old copper pitcher in the office poured many a warming ale. John Guy Vassar was one of the yacht owners.*[169]

Colonel Rogers owned the *Jack Frost* and the *Ariel*. FDR (before he was stricken with polio) owned the *Hawk*.

Archibald Rogers.

Other sports on the great Hudson River estates included skiing, tobogganing, polo, golf, tennis, swimming, baseball, bowling, croquet, boating, fishing and fox hunting. The "river families" (which they liked to be called) had the time and the money to devote to such pleasures. "In 1890, the James Roosevelt family returned from a trip to Europe with some slender mallets (similar to those used for croquet) and several little white balls. They were the main ingredients for a new game called 'golf.' The Rogers and Roosevelt grounds along the Albany Post Road were so extensive that the two men and their servants laid out a six-hole course and began spending their afternoons playing golf."[170] Thus began one of the first golf courses along the Post Road. There are dozens now.

Expensive Travels

If not at home playing sports or partying, the river families would travel all over the world. The family social life would follow a pattern:

About the middle of November, the Vanderbilts would go to New York City for the opera and social season, staying at their townhouse until

the end of January. On weekends in this period and at Christmas, they usually returned to Hyde Park. March and April were generally spent at Palm Beach, Fla. Here the Vanderbilts and their guests would cruise on their yacht in southern waters. For variety they sometimes leased a large estate on the West Coast, the family making the trip there and back in its private railroad car. The Vanderbilts would return to Hyde Park about Easter, remaining until shortly after the Fourth of July. Between then and Labor Day, they usually went to one of the several summer mansions that they owned at various times. The first of these was Rough Point, at Newport, Rhode Island. Part of the summer might be spent in Europe. The Vanderbilts would cross the Atlantic on an ocean liner, having sent the yacht on ahead. Then they would pick up the yacht and cruise along the coast of Europe or in the Mediterranean.[171]

The Roosevelt family also traveled extensively, but on a less grand scale. FDR's mother, Sara, was a Delano from across the Hudson River in Newburgh. Both the Roosevelt and Delano families had been around a very long time and were very large, so FDR's family traveled a lot to visit relatives not so far away. Each summer, however, they would travel to a spa at St. Blasien, Germany, so that father James could "take the cure." He suffered from a heart condition for many years. The Roosevelts, like the Vanderbilts, also had a townhouse in

Vanderbilt mansion.

New York City. The Roosevelts traveled each year, as well, to their retreat property at Campobello, a Canadian island off the northern coast of Maine.

In the Rogers family, Colonel Rogers and his sons did most of the traveling. Colonel Rogers was a mystery man, of sorts. When in Hyde Park, he appeared to be a moneyed aristocrat, but he also led a double and triple life as a cowboy and mountain man. "For 24 consecutive years, Col. Rogers made big game hunting trips to his ranch out west and for more than 45 years went fishing at his lodge in New Brunswick, Canada."[172] Mrs. Anne Rogers would stay home, and of all the women in the three river families, she was the most liked by the people in the hamlet.

EXPENSIVE PARTIES

The Rogers family was famous for their hospitality, especially their New Year and Christmas parties:

> *Frequently there would be 100 guests stepping out on the featherbone floor. There were the popular Merry Widow waltzes. "My Hero" from "The Chocolate Soldier" by Oscar Straus, was a favorite, and there were dance tunes from "Girl on the Train," Lehar's light opera. Society was represented at Crumwold Hall (the Rogers Mansion) by the Astors, the Huntingtons, the Chanlers, John J. Chapman, Colonel Zabriskie, R.V. Suckley, Tracy Dows, some of the Roosevelts, the Delanos, the Vanderbilts, and others. The climax of the New Year Party came at the stroke of midnight when all present, it was said, would draw the chairs to the center of the hall, stand on them and give a toast to the new year with raised glasses of champagne. A former servant recalled that rum punch was one of the favorite drinks, ladled from a silver bowl—one of Col. Rogers' ice yachting trophies.[173]*
>
> *...At Christmas time in Hyde Park, there was also a big party at Crumwold Hall, complete with Santa, and a big tree, and presents. Anne Rogers was seven in December 1901, and waited by the tree, the huge tree from their woods topped by a wax angel with gossamer wings,*

its branches covered with little glass trumpets that you could really blow, glass bells that really tinkled, hundreds of candles, French dolls, monkeys on sticks. Outside the room, she heard the sound of sleigh bells. When they ceased to jingle, Santa made his appearance, with long white beard and beetling eyebrows and a pillow stuffed in front of his red suit. He began handing out toys from his well-stuffed pack, calling all the children by name. How did Santa know their names, Anne wondered? When her turn came, she kissed Santa on the cheek and felt a mask and, peeking behind the mask, recognized a familiar face, who disappeared into the end room on the third floor, bidding a merry Christmas to all. Anne Rogers realized that Santa Clause did not exist. The man with the mask, the giver of gifts, was Franklin Roosevelt.[174]

Dutchess County Hunt

Not all of the river family parties were indoors. Every spring and autumn, an event took place that was a pretty obvious attempt to show a connection between the new money of the Hudson River gentry and the old money of Europe, England in particular. The Dutchess County Fox Hunt would take place along the Albany Post Road. It would usually start at either the Roosevelt or Rogers estates and finish five miles up the Post Road (and a couple side roads) at Pleasant Plains.

Before the "hunt," somebody would drag a dead fox or scent bag the entire length of the five miles. The estate owners and invited guest riders,

dressed in their bright red, English costumes, riding on muscular horses, followed a pack of frantic hounds. They would race cross country, jumping stone walls and fences while women would watch and cheer as they more politely followed along the Post Road. The scent bag would be purposely dragged near the Post Road to afford a better view to spectators. Several sightseers would be seated in an English coach facing each other. The coachman would ride in front on the box seat, high up, and footmen rode in the rear, taking turns blowing shrill notes on a long tapered coach horn. When the hunt was over, there would be a lavish picnic at Pleasant Plains. There would

be rewards and rest for the hounds and horses, and champagne toasts for the riders and spectators.[175]

Sara Roosevelt (mother of FDR) once wrote, "Franklin not only hunted like other boys, but learned early, and on his own initiative, to follow when the grownups rode to the hounds. One morning, just as the hunt club reached the end of the chase, Franklin came galloping up behind them on his pony, Debby."[176]

Horse Power

During the Gilded Age, the main horsepower was real horse power. Automobiles were just coming into style, but all kinds of horse transportation could be found on the estates. There were wagonettes, old Vermont buckboards, phaetons, stanhopes, broughams, landaus and even two-wheel English carts:

Colonel Rogers, Ogden Mills, or James Roosevelt, and others, used to come down the Albany Post Road to Poughkeepsie in their English carts to get their mail. The master drove and the servant sat—precariously sometimes—in the rear box, back to back fashion. The latter would slip into the post office, get the mail and dash back to the cart, handing his master the letters. He had to be quick to jump aboard. The story is told of how once James Roosevelt started off without his footman, and didn't find out until he got back home. The footman, an Englishman, and green, was the object of merriment when he returned, for he complained, "You didn't wait for me!"[177]

The Hudson River gentry also had a polo team, with "home" matches played on the flat part of the Crumwold front lawn along the west side of the Albany Post Road. It is probable that Colonel Rogers and his sons played on the team, and it is also supposed that even Franklin Roosevelt was a member before he was stricken with polio. It is known for sure that the president, in his youth, played for the Hyde Park baseball team called the Robin Hoods. By May 24, 1936, the polo field had been converted to

Horse and carriage at Vanderbilt estate.

the town baseball field. From his home, the president and his entourage drove the short distance up the Albany Post Road to watch his former team play a team from Columbiaville, Columbia County. The Gilded Age was over and the Great Depression had set in, but life was still pretty good in Hyde Park.

THE THREE ESTATES TODAY

The Roosevelt and Rogers estates saw tremendous transformation during World War II. The federal government had purchased the Rogers estate and used it to house 306 military police who protected President Roosevelt, who lived next door. All along the Albany Post Road, there were guard shacks and police dogs every couple hundred feet. The two estates resembled an army camp until FDR died in 1945. Today, the Vanderbilt estate and the Roosevelt estate are both owned by the National Park Service and are popular tourist destinations. The Rogers estate is privately owned.

The Rise and Fall of Woodcliff Pleasure Park

Just north of Poughkeepsie at milestone 83, there once stood a beautiful mansion occupied by industrialist John Flack Winslow (1810–1892). Winslow held the first American patent rights for the Bessemer steel process and was one of the owners of Corning and Winslow Ironworks in Troy, New York.[178] Because Winslow wanted to retire among his fellow newly rich aristocrats, in 1867 he chose a beautiful, but relatively modest, twenty-five-acre estate located between the Albany Post Road on the east and the Hudson River on the west. It even had its own dock on the river so that Winslow could sail his fancy luxury yacht to his home.[179]

THE BATTLE OF THE *MONITOR* AND THE *MERRIMACK*

Winslow moved to Poughkeepsie five years after he played a key role leading up to one of the important battles of the Civil War. Information from Northern spies had reached Washington, D.C., in late 1861 that the Confederates were building an ironclad gunship at Hampton Roads, Virginia, to break the Union blockade of Southern ports. John Ericsson and his associate, Cornelius S. Bushnell, had tried for weeks to interest Washington officials in their version of an ironclad gunship, which Ericsson named the *Monitor*. (The *Monitor* was often called a "cheesebox

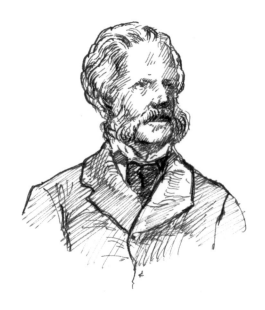

John Flack Winslow.

on a raft" because of its low profile and round "box," which held a rotating gun turret.) Winslow, a personal friend of Secretary of State William Seward, was approached by Bushnell and arranged for a meeting with President Abraham Lincoln. After looking at Ericsson's drawings and listening to Winslow's financial arguments, Lincoln approved the project with the quaint remark: "Well, I think there is something in it, as the girl said when she put her leg in the stocking."[180]

Winslow advanced all of the money to build the warship, and since the navy was slow to make payments on Winslow's bills, Winslow still owned the *Monitor* when it steamed into Hampton Roads to do battle with the *Merrimack* on March 9, 1862. His role in the *Monitor* victory has been forever overshadowed by the hero worship given to John Ericsson. If it wasn't for the managerial skill of Winslow, there never would have been a victory.

WOODCLIFF, WINSLOW'S RETIREMENT HOME

Winslow's home at Poughkeepsie was one of the best of eighty or so mansions that lined the east bank of the Hudson River. It contained thirty-five rooms of varied sizes, and the exterior was made of brick,

which Winslow had covered with "clapboards to give it a mid-Victorian appearance. There was an attractively furnished drawing room on the left when you entered and a huge dining room across the width of the building with two fireplaces."[181] Winslow also added "pillars and steps, with lots of gingerbread on the porches, and a mansard roof with Victorian shingles."[182] The mansion was curiously shaped, somewhat like a sailing ship, with a magnificent 150-foot-tall watchtower (another Winslow touch) on the south end resembling the ship's mast. On each flight of stairs in the "tower was a little room, with windows on three sides. Some of these were colored, with sections in violet, yellow, red, and other colors, giving a beautiful effect when the sun shone through them."[183]

Across the Post Road on the east side (now the parking lot for a Home Depot) were the farm barns and stables. "There were handsome teams on the estate, and the Winslow carriages were customary sights to the townspeople. In the winter there was a magnificent sleigh; the occupants kept warm by bear robes whose heads were hung over the back. The coachman sat aloft and the jingling of the sleighbells made grand music on crisp winter days."[184]

John Flack Winslow died in 1892, and his wife died in 1926. Thereafter an auction of the Woodcliff property was held on December 19, 1926. It was one of those events that make you wish you had been there. For some strange reason, items were being hammered off at ridiculously low prices:

> *A large antique Chinese gong and stand was purchased for six dollars… an antique barometer, which was carried on a Union gunboat, encased in mahogany, measuring three feet in length, went for $12…a beautiful candlestick at least 100 years old went for $68…and most surprising of all, a Florentine 15th Century table, fashioned in various types of wood, beautifully inlaid in various colors, and with brass figures at the corners went for $25.* [185]

The Rise of Woodcliff Pleasure Park

The land and buildings were at first purchased by Mr. and Mrs. Marion and then (six months later) purchased from them by Fred Ponty. He immediately began converting the Victorian estate into an amusement

Blue Streak construction.

park (or pleasure park, as they were called in those days). "He tore down the stables and stableman's house, but left most of the other buildings intact."[186]

The Winslow family had begun work back in 1918 on a large "cement basin" and had it filled with water from a stream that flowed through the estate. Ponty remodeled the basin, and it soon gained fame as the largest swimming pool on the East Coast (it could hold three thousand bathers at one time).[187] Winslow's mansion became the inn that served the park. Known as Woodcliff Pleasure Park, the park was popular in the late 1920s and 1930s, and day liners would steam up the Hudson River with boatloads of excursionists from New York City. The previously mentioned stream was dammed up a few hundred feet above the pool, and boat rides with a tunnel of love were added. Other attractions included a roller rink, a boxing rink (near the pool), bumper cars, an arcade, a carousel, a picnic pavilion and pony rides.[188] Even the ticket gatehouse on the Albany Post Road became famous. It was highly ornamented and painted a gaudy pink color.[189]

One year after the Cyclone roller coaster opened at Coney Island, its successful designer, Vernon Keenen, was commissioned to draft plans for an even more spectacular coaster, the Blue Streak, at Woodcliff Park. Built by contractor Harry Baker in a ten-acre orchard, where Winslow had planted hundreds of apple and pear trees on the northerly side of his estate, it was opened in early 1928. Keenen and Baker did their jobs well. The Blue Streak held the record for fastest coaster (65.2 mph) until 1981 and longest drop (140 feet) until 1977. The scariest part of the ride was a fast turnaround perched precariously on the edge of a high cliff (the cliff that gave Woodcliff its name) along the east side of the New York Central Railroad tracks. On the west side of the tracks was another 60-foot drop to the Hudson River. Few people had time to enjoy the panoramic view, however, as they whipped around the turn and immediately dropped the 140 feet into a natural ravine. The roller coaster and entire park were the pride of Poughkeepsie. It seemed to everybody that Woodcliff Pleasure Park would be as famous as Coney Island (but without the sand).

The Fall of Woodcliff Pleasure Park

The park only held prominent status for a year and a half, however. The stock market crash of October 1929 and the Great Depression of the 1930s limited almost everybody's spendable income. Robert Arata, a longtime Poughkeepsie and Hyde Park resident, stated: "If my buddies and I couldn't find a dime to get inside the pool fence, we would climb a tree on the outside of the fence behind the bathhouse, jump to a branch on a different tree inside the fence, and get in that way."[190] In an attempt to attract more paying customers to the park, the park management convinced the City of Poughkeepsie to spread waste sand from the water treatment plant sand filter along the Hudson River shoreline near the former Winslow dock. The park saw almost no increase in income, however, partly because the same sneaky kids could find their way to the beach with no trouble at all. In a story reminiscent of Tom Sawyer or Huckleberry Finn, Bob Arata also told about the time when he and several of his buddies were skinny-dipping in the river one evening: "Some high school girls came by and wouldn't leave.

Swimming pool, 1930s.

After a long time, I swam around a point in the shoreline, climbed the bank of the river, ran across the railroad tracks naked, snuck into the Woodcliff Pool by climbing the fence, and borrowed some of those rental swimming suits, which had the straps over your shoulder. Then I had to sneak back to the river, and my buddies were able to put the suits on underwater."[191]

Bad publicity sometimes plagued the park. Once a man named Howe stood up in his seat as the Blue Streak was making the turnaround at the top of the cliff. Only lap bars were used to hold passengers in the cars, so the idiotic Mr. Howe was catapulted out and was flung more than one hundred feet to the ground below. Another time a man was assaulted by a grounds superintendent for "fooling around" on the bumper car ride. After the superintendent was arrested, the victim explained to the judge that he thought the purpose of the bumper cars was to "fool around."

RACE RIOT

Finally, an incident happened on August 10, 1941, that created the ultimate in bad publicity:

Hurling rocks and bottles and brandishing knives and a hatchet, rioting New York Negroes yesterday afternoon caused extensive damage to buildings at Woodcliff Amusement park, smashed windows and windshields of police cars and misused scores of picnickers at the Amusement place.

State Police in Dutchess County, attaches of the sheriff's office and 22 city policemen rushed to the park in response to riot calls sent out over teletype and radio systems. For more than a half hour, they battled the enraged crowds.

One deputy sheriff said that he was "knifed" in the leg, as he sought to place one of the rioters in custody. Another reported his wallet containing $25 and a badge were taken from him. Clubs were wrested from others.

Children in the pool were endangered as large rocks and bottles were hurled at them. Two police cars and two other automobiles were badly damaged as the unruly crowd of Negroes ran amuck in the amusement park before authorities arrived.

Women, who were attending an outing sponsored by St. Joseph's Church club, ran to safety as Negroes moved into the inn and hurled stones and rocks at mirrors and windows. Chairs, benches, and tables in the grove were upset.

Sheriff Close said last night that District Attorney Schwartz would be asked today to conduct a full investigation of the incident, which was described as "the worst outbreak of trouble in Dutchess County in many years."

Approximately 3000 members and friends of a Negro lodge in New York City arrived at the amusement park at about 2 p.m. aboard the steamer "State of Delaware," piloted by Captain George H. Stenken. The St. Joseph's church club outing was in progress and more than 1000 men, women, and children were in the park and inn.

Deputy Sheriff Joseph Bloomer, who was on duty in the park, was asked by the committee in charge of the Polish club outing, to instruct

the New Yorkers not to enter the inn, which was rented by the club from the owner, Mrs. Catherine Runk, for the day. Some of the Negro men objected to being kept out of the inn and they entered the building, it was said.

Bloomer ordered the beer taps locked, and as he did, rocks were hurled against mirrors and through windows of the inn.

George Buschbaum, a court officer, who was in the inn at the time rushed to a telephone booth and called the sheriff's office, reporting "trouble." He said that he was threatened in the booth by a Negro, who brandished a knife, and he departed from the booth as several men followed him.

Women and children fled from the park, seeking shelter from the virtual shower of rocks and bottles. Passing motorists stopped and later sent word to city police, reporting the riot.

Shortly before 3:45 p.m. Lieutenant McLaughlin received a call for assistance. He communicated with Mayor Schrauth, who consented to city policemen responding to the riot call. Approximately 22 men rushed to the scene in prowl cars and the police patrol.

Meanwhile teletype and radio calls reached every available trooper in Dutchess County, and Lieut. Walter Reilly responded in charge of the men. About 24 deputy sheriffs in charge of Undersheriff Crapser rushed to the park, and finally subdued the enraged crowds.

Sergeant Frank Van Wagenen and Undersheriff Crapser detained several members of the committee in charge of the New York outing. They later released them pending further investigation.

Bricks were thrown through windows of the sheriff's "ghost" car, a city police car, and an automobile owned by Frank Christopher, 33, of 143 Mill Street. Ignition wires were ripped from Christopher's car and other damage was done to the machine. Christopher told authorities that a rock struck his daughter's shoulder as she was in the swimming pool.

Deputy Sheriff Bloomer's automobile was badly damaged, and attempts were made to overturn the car.

Deputy Quinlan's nightstick was yanked from his hands by a group of colored women, authorities said. Quinlan had clouted the wrist of a Negro, who he said had a hatchet in his hand swinging it near Deputy Sheriff Donald Holden, who was in the midst of the rumpus in the

inn. Deputy Sheriff Adams grabbed the hatchet and hurled it through a window.

In the melee, Adam's pocketbook was snatched from his pocket. The wallet contained $25 and his deputy sheriff's badge. Quinlan reported later that a Negro attacked him with a knife, cutting his thigh.[192] Quinlan took one man in custody but several other men seized the prisoner and rushed him through the crowds.

"One man was swinging a hatchet at Deputy Holden when I clouted his hand and knocked the hatchet to the floor of the inn," Quinlan said. "Several women grabbed my club and disappeared in the crowd with it."

During the early part of the riot, police rushed to the Woodcliff dock and directed Captain Stenken to sound the whistle of the steamer in an attempt to attract the New Yorkers to the boat. About 24 State troopers, city police, and deputies ordered the Negroes from the park and authorities lined the walks and dock as they boarded the boat.

While police guarded the dock and bridge spanning the New York Central railroad tracks, word reached the crowd on the boat that the "committee was in custody." Between 300 and 400 Negroes left the boat and attempted to break through police lines to return to the park, but were held back by authorities.

Undersheriff Crapser released committee members pending further investigation. Sheriff Close said that he would confer with Mr. Schwartz today to decide what action would be taken. He hinted that a grand jury investigation might be asked.

"We'll have no more riots in this park," the sheriff said. He recalled that a minor outbreak of trouble resulted about a month ago when about 3,000 New York Negroes arrived at the park and hurled stones after they claimed they were refused admission to the swimming pool.[193]

No further items appeared in the Poughkeepsie paper about the riot, so it could be assumed that the grand jury never did a thing. It should be noted that summers in the 1940s were some of the hottest on record. Any refusal to the park or swimming pool would have enraged a crowd that had made the hot three-hour trip up from New York City. Also, the early 1940s were a time of Jim Crow laws and discrimination, and the black

crowd would have felt wronged. The owner of the park certainly made a serious mistake by scheduling both the Polish club and the New York excursionists in the same inn at the same time.

The park shut down for repairs and cleanup but never reopened. The inn (Winslow's former mansion) was damaged beyond repair and was turned into a salvage site only. "The beautiful woodwork—mahogany paneling and staircases—and other structural and decorative parts were removed bit by bit, until the structure became unsafe. It had to be ordered torn down by the local administration."[194] In 1942, the Blue Streak was dismantled, and other park buildings were burned. Scrap lumber from the Blue Streak was used to build a bee house for the Marist brothers, who owned a seminary on adjoining property to the south. The bee house held equipment to extract honey from thirty hives. About this time, the brook that once flowed through the property was piped and covered. During the 1980s and 1990s, townhouse dormitories and an athletic field for Marist College were built in its place.

The riot at Poughkeepsie was only the beginning of trouble for Captain George Stenkin and the steamboat *State of Delaware*. On August 17, 1941, exactly one week after the Poughkeepsie riot, another group of three thousand blacks rioted on the steamer dock in New York City. The second riot was started because some gangsters had counterfeited tickets for the boat. Police and the excursion organizers tried to find the five hundred fake tickets, the crowd became unruly and there was a mad crush toward the boat. Three women were trampled to death. That riot made it into the national news media. The Poughkeepsie riot didn't.

The Unsolved Murder of Surveyor Frank L. Teal

E ven in the mid-twentieth century, once a traveler in the Hudson Valley ventured off the Post Road, he very likely would find himself bouncing along on winding, hilly and rutted dirt back roads. One of those roads was Stone Church Road, about halfway between the villages of Rhinebeck and Red Hook in Dutchess County. Highway crews would save these difficult roads for last when it came to repairs in the summer or plowing in the winter. Most people who lived on the back roads would complain that the town should use their taxes to fix the darn roads, but there was one man who seemed to enjoy the isolation.

OLD-FASHIONED LIFESTYLE

Frank L. Teal wasn't exactly a hermit, but he was very close. He was born in a sturdy eight-room house on Stone Church Road about two miles east of the Post Road in 1867 to parents of Palatine heritage. He still lived in the same place in 1949 at the age of eighty-two. In all that time, very few improvements had been made to the house; it had only been painted a couple times, and vines would often envelop the place up to the roofline. Water was still hand-pumped from a well in front of the house, and an outhouse in the back served as a bathroom. No electricity had

been brought to the property, so kerosene lamps were used. No telephone provided instant communications with the neighbors; letters and parcel post were the slow methods. A butcher in Rhinebeck would even send supplies of meat to the Teal home by mail on a weekly schedule.

The inside of Frank's home was as stark as the outside. Most of the furniture, including a large piano, had been pushed against the walls and covered with sheets and blankets. On top of the blankets would be piled books, magazines and Frank's surveying papers. For the occasional guest, a few stiff and uncomfortable chairs and a black horsehair sofa were left uncovered by clutter. With no electricity or radio, family entertainment was provided by the piano (when it was uncovered), a flute, an oboe and a very old, hand-cranked gramophone ("a wooden box with no lid and a loud speaker in the shape of a horn attached to the handle, which holds the needle"[195]). There was no furnace, so two wood-burning stoves on the first floor heated the two-story house. The house was an anachronism, and so was Frank L. Teal.

In his youth, he would walk everywhere he needed to go; he had no need for a horse. As he reached adulthood, he afforded himself the luxury of a bicycle, complete with a speedometer and watch strapped to the handlebar. Although he refused to own a car, he occasionally would accept a ride from a kindly neighbor or friend.

Surveyor and Gentleman

By all accounts, Frank was a serious but friendly guy. Everybody knew him and liked him, although they probably wondered about his eccentric habits. He had lived at his Red Hook home all but a few years. His chosen professions were surveying and civil engineering, and to those ends he had wandered far from home only once to receive a higher education:

After graduating from Hartwick Seminary [now Hartwick College] *in Oneonta, N.Y., he taught school for a time in Germantown, then went to New York City, where he got most of his engineering training in the office of famed bridge engineer David B. Steinman. While there, during the 1890s, Teal worked on the City Transit System and various*

Surveyor Frank L. Teal.

big bridge projects. He then decided he wanted more formal education, and entered St. Stephens [now Bard] *College with the Class of 1901. But when his father died in 1899, he returned to the family farm and went into business as a surveyor to support his mother and two sisters.*[196]

For a fifty-year period between 1899 and 1949, Frank L. Teal was the only surveyor in the northwestern Dutchess/southwestern Columbia County area. Two devastating world wars and the Great Depression occurred during his career, but his business monopoly could have made him a rich man. However, that didn't happen. He insisted on using the same nineteenth-century transit[197] with which he had started and never once raised his prices during the fifty years.[198] "It is reported that after surveying the Bard campus for its WPA-built 'barracks,' the contractors in Kingston returned his bill, saying it was too low to be acceptable to the authorities in Washington."[199]

Somehow he would strap his transit, steel tape, transit legs and other bulky equipment on his bicycle and bounce along for miles to reach his

job site. Customers would wonder how he kept his transit in adjustment, and many of the wealthier clients who lived on the great estates along the Hudson River would send their chauffer to pick him up. His client list of more than one thousand included the Roosevelts, Dinsmores, Dowses, Astors, Millses and Livingstons. His two biggest engineering jobs were the Red Hook water system and the Rhinebeck School.

Robert L. Decker, "who worked with Teal and inherited his records,[200] recalls that…he did everything the long way, by hand.[201] He kept his records in old envelopes saved from incoming mail. Benson Frost, who knew Teal well, recalls that his sister could never get him to eat regularly; if Teal was in the field at meal time, he would work on until he was done. He feared that if he took a break, the second part of his figuring would be in a different shade of ink."[202]

Frank Teal was a traditionalist in the way he dressed for work. During the nineteenth century (and perhaps before), surveyors would wear clothing out on a field job that would seem appropriate in the office today. He would invariably wear a light-color, flannel three-piece suit with a white stiff collar shirt and black tie. On his head he wore a felt fedora or sometimes a derby. For wet or winter weather, his legs were covered with "buttoned kaki gaiters, above which his heavy outdoor black and white speckled trousers bagged grotesquely."[203]

ALWAYS A BACHELOR

When Deborah Dows once complimented Frank on his surveying skills and asked him why he had not moved to a big city to earn a better income, Frank answered her by stating that "happiness is not to be found by going out into the world, but rather, that it is to be found at home, by giving pleasure to others, by lightening other peoples' burdens. When I realized that truth I didn't need to leave home. There was enough for me to do here."[204]

Frank remained a bachelor his entire life, at first living with his parents and two sisters and then, toward the end of his life, with his only remaining sister, Eve. While at Hartwick Seminary, he apparently fell in love with an Oneonta girl, but alas, she married another. "For

many years Teal, at Christmas or Easter, would send a small gift—often a bunch of violets—to the lady, and she would write to thank him and relate her news of the previous year. Even this interchange stopped long before he died."[205]

Frank's mother died in 1942 at the age of ninety-six, and Frank's sister, Eve, died in May 1949 while in her seventies. So Frank was alone, living the life of a lonely old man of eighty-two. His nearest neighbors, the Zietz family, were half a mile away on Stone Church Road. Shortly before Eve died, she had asked Mrs. Isoline Zietz to look in on Frank every day and make his supper meal, and Mrs. Zietz had agreed. To do this, Isoline came by in the evening, prepared the hot meal on one of the wood-burning stoves, chatted with Frank while he ate and left a glass of warm milk for him to drink while he did paperwork on his survey projects. The next morning, she would come by to clean up.

Murder scene: Teal's cluttered office.

The evening of December 22, 1949, was like all the others since Eve had died, except for one thing—it was Frank Teal's last evening. The county coroner calculated that some time between ten and eleven o'clock that night, somebody approached the west window of Frank's work room and shot a .22-caliber bullet through Frank's head. As usual, Mrs. Zietz came by the next morning, but when she found the door locked, she didn't come in to clean up. She later told the police that she assumed that Frank had left home early in the morning and had mistakenly left the door locked.

Gruesome Discovery

All day on December 23, Mrs. Zietz felt uneasy, so when evening came, she took her nineteen-year-old son with her to the Teal house. Again finding the door locked, she sent her son to a back window, which he pried open. Immediately, he cried out that there was smoke in the house but crawled through the window anyway. Entering Frank's workroom, he was shocked to find an unrecognizable, blackened corpse smoldering in the remains of a rocking chair by the stove. "He [Frank] was clutching the charred remains of a five and one dollar bill in his burned hands."[206] In an apparent attempt to cover up the crime by burning the house down, whoever had shot Frank had dumped the contents of one of the kerosene lamps on Frank and set him on fire. The house was closed up so tightly, however, that the fire only burned Frank and his rocker.[207] "The windows of the house were smudged by the heat of the fire and smoke."[208]

There were no relatives, other than a distant cousin, left to mourn the loss of such a fine and noble person. Many friends and neighbors were deeply saddened, but they could console themselves knowing that Frank never knew that his instant death was coming. He had begun a survey for Fred Cotting in Red Hook on December 22 and probably worked until late afternoon. He had drunk half a glass of milk just before the very moment of his death.

State and county police investigate crime scene.

Motives?

Why would somebody murder such an innocent old man? State police investigators and Dutchess County district attorney J. Vincent Grady tried their best to answer that question, but every lead went cold. The state police had fifteen men on the case for several weeks (at a time when that number of manpower was unusual). People in the Red Hook–Rhinebeck area were scared.

The most obvious motive was robbery. "A watch owned by Mr. Teal and possibly some money, were missing from the house."[209] Was he counting money while sitting in his rocking chair? "It was reported that he had cashed sizeable checks in the Rhinebeck Bank the day before the murder. It was rumored that he had given a $100 bill to a neighbor 'to buy a washing machine.'"[210] The district attorney stated in the newspapers that

he wished anybody who had received a $100 bill since December 22 should report it to the police. Several bills showed up, but none had a suspicious origin.[211] Perhaps a drifter had killed Frank, but that seemed unlikely, because his house was so far east of the Post Road, the usual route for tramps.

Perhaps some punk teenagers shot Frank. A search was organized for .22-caliber guns in the possession of teenagers, and several were found. Two boys (one was the Zietz boy who had found Frank) were arrested for illegal possession of a dangerous weapon, but they had alibis from several people.

Other motives were explored: a disgruntled client or maybe the loser in a property line dispute? Even the motive of jealousy was raised. "Ink-scribbled postcards were received at State Police Hq., the DA's office, and The Poughkeepsie New Yorker, stating that jealousy was involved. But these never led anywhere. After all, Frank was 82 years old!"[212]

ONE GOOD LEAD

Finally, in mid-January, the police thought that they had their man, or more correctly, a fifteen-year-old boy. He had run away from a foster home in Red Hook and was arrested on petty larceny charges in Germantown, Columbia County. During interrogation, he confessed to killing Frank[213] but then told the police so many incorrect details about the crime scene that forensic psychiatrists concluded that he had made the whole thing up. He also had no means of getting to the Teal home on December 22, 1949.

The youth was sent to reform school but, a year later, escaped and returned to Columbia County. He stole a car in the town of Livingston, was picked up on the Post Road and was rearrested. Again he claimed to have killed Frank but "then recanted his confession, saying that 'he liked to see the police running around.'"[214] He was sent back to jail and apparently stopped confessing to the Frank Teal murder.

ANOTHER POSSIBILITY

The author of this book, a few times during his life, has heard elderly or sick people say something like, "I'm so old, I wish somebody would just shoot me." Wouldn't it be strange if Frank Teal was also thinking the same thing? His last close relative, Eve, had died in May 1949, and eighty-two-year-old Frank was living alone in that big old house with no way to "give pleasure to others" or "lighten other people's burdens." He had such a strong character that maybe he took some of his $100 bills and paid somebody to shoot him when he least expected it.

The 1963 Poughkeepsie Book Burning

P rogress is sometimes accompanied by tragedy. In the case of the 1963 bypass of the Albany Post Road in Poughkeepsie, the tragedy came in the form of a tremendous historical and cultural loss.

An elderly man named John R. Lindmark owned the 120-year-old former Christopher Columbus School at 55 Church Street. The New York State Department of Transportation needed to tear down the building, which had been converted into an antique book store, because it was square in the way of the new Post Road arterial highway. The beat-up old building was not very valuable, but what was inside it most certainly was.

The house contained more than 131,000 old and rare books,[215] worth more than $3 million. Lindmark had built his inventory by purchasing personal libraries from several auctions at old Hudson River mansions, and his rare book business was known throughout the country. Among his customers were universities, libraries and famous people. President Franklin D. Roosevelt had purchased many of Lindmark's books.

STUBBORN BUSINESSMAN

Lindmark, known to the neighborhood children as a scary and mean old man, was a good businessman but also a stubborn one. When the state first offered to purchase his property in 1961, he simply refused. Two years of court hearings, offers by the state, refusals by Lindmark and eviction notices followed. Lindmark lost every court case and legal challenge that he fought. The national news media began to carry the story, and many local civic groups and institutions offered to help him move and store the books: "Two local colleges offered to store the books and the City Board of Education offered to give them shelter in their many school buildings...the huge Vanderbilt barn and coach house that had become the Hyde Park Playhouse [were offered]...Suburban housewives began to recruit their friends who had station-wagons to help transport the books and local students signed up to form 'bucket brigades"[216] Lindmark refused all help; his point was that the state must pay and pay dearly.

The old school building became a famous bookstore.

"Mr. Lindmark, who had been in business here for a half-century, was offered $22,000 for the site…But he contended it would cost him $200,000 to find a new building, equip it with shelves and move [the] volumes."[217] Mr. Lindmark also maintained that "Governor Rockefeller had 'pocketed' a bill, passed by the Senate and Assembly last year, granting him $175,000 to cover the cost of a new building, moving and replacement of book stacks."[218]

In April 1963, the state finally had the Dutchess County sheriff physically evict Lindmark and his 131,000 books. They were stacked on the sidewalk in front of his building, as is the usual procedure in cases of eviction. Now the news media really had a story to tell:

> *Scores of schoolchildren and adults kicked and trampled their way today through* [thousands of] *books stacked along a 400-foot lane…*[A discouraged Lindmark said,] *"I never look back at a dream,"…He placed a value of $3,000,000 on his stock of histories, biographies, diaries, genealogies, and books of art and fiction…Mr. Lindmark particularly bemoaned the loss of a manuscript on the career of John Jay, first Chief Justice of the United States and the diaries of Thomas McKeon, a signer of the Declaration of Independence.*[219]

Near Riot

Once the books were out on the street, a few curiosity seekers showed up; then it was a few dozen, but soon it grew to a few hundred. One reporter claimed that the crowd numbered one thousand. Men, women and children came to see what was going on. Some people began to look at the books, and if the book didn't suit their taste in literature, they would toss it aside. Then everybody began to paw through the stacks, which became a disorganized heap of rubble. The pushing and shoving mob trampled over discarded books and even fought with an "I saw it first" attitude. Hundreds of normal people became vandals and looters in only a few moments. Not only did they give one another black eyes, but the riot also gave the city of Poughkeepsie a symbolic black eye. Television crews arrived the next day to record the aftermath of the chaos. Just

John R. Lindmark (left) is served with eviction warrant by City Marshal Soloway.

a year after the Cuban missile crisis, 1963 was a time of international tension and the Cold War. Even the Soviet press picked up the story. One headline in *Pravda* read, "Only in America."

Because of all the legal and eviction confusion, the Lindmark building was left open. William F. Gekle, an author from Milton (across the Hudson River) wrote:

> *I went inside, stepping over a pile of books resembling rubble, or rubble resembling books, in the doorway. It was almost unbelievable in there. Outside the building there was chaos; inside it was quiet. One heard footsteps now and then, the slow, deliberate steps of the browser. I looked down an aisle, shelves on both sides, neatly lined with books.*

*One or two people standing in the aisle, quietly, reading, as in a library.
In several other aisles I found readers and collectors. I recognized some
of them as faculty members of local schools and colleges. They were
quietly making their selections.*[220]

After days of sorting, discarding, misusing and stealing books,
the looters disappeared as April showers finally arrived. The heaps
of books became a slippery, stinking mass of paper and glue. One
eyewitness wrote:

*In the manner of one irresistibly drawn back to the scene of a crime, I
went back for one last look at the evicted books. The City Marshall was
right. There had been several light showers, and the damp, stuck-together
mass of paper was hard to identify as a collection of books. Fascinated
by the enormity of the destruction, I walked along outside the fence. (I
couldn't make myself walk on what had once been living literature) and
peered through the wide cracks in the fence. Only one man was prodding
the remains. As I watched his activities, I saw part of a book lying
in his path, spread open to reveal a full-page steel engraving. To my*

Hauling books to be burned.

astonishment it was a reproduction of my husband's mother, painted in her girlhood by John Singer Sargent. "Please," I heard myself calling to the man on the other side of the fence, "would you mind handing me that book with the picture? It's my mother-in-law."[221]

The City of Poughkeepsie was forced to declare the mess a public nuisance and began to truck the fifty tons of former rare books to the county incinerator.[222] The books were actually burned. The nation was horrified. Poughkeepsie was doing the same thing that Hitler had done, only on a much bigger scale.

After writing about this incident, the author of this book has asked himself this question: "Would I have been part of that mob that looted the books?" The answer is, "Probably, yes." Hopefully, I would have been there to help save the books, but who knows—maybe I would have grabbed some books and ran.

Milestones

The author has searched for, photographed and mapped every milestone marker on the Post Road on the eastern side of the Hudson between the Battery in Manhattan and the old ferry at Albany (Greenbush) that the author was able to find as of the year 2008.

Finding all of the markers was difficult. For example, only three and a half markers (out of fifteen) still exist within the boundary of the city of New York. Milestone 12 is set in the wall at the south entrance to Isham Park on the west side of Broadway, and another, milestone 11, is in the backyard of the Morris-Jumel Museum. The remains of another, no. 7, is in a small park at the intersection of St. Nicholas Avenue and 117th Street. It seems that the greater the population of a place, the less chance a milestone had to survive. In Westchester County, with all its development and the construction of the Croton Aqueduct in the 1800s, more than half of the markers have been lost or were moved. In some cases, the move was three miles or more.

PRESERVATION

However, in contrast, in rural areas such as Hyde Park and Rhinebeck, all or most of the monuments have been saved from destruction. Some

Only a piece of milestone 7 still remains.

people give the credit for this to President Franklin Delano Roosevelt, who loved history and lived in Hyde Park. FDR's most popular social relief program was the Civilian Conservation Corps (CCC), and the organization built protective stone covers for most of the milestones found today along the Post Road.

The Old Road Historical Society in Garrison has also done much to preserve seven milestones plus several miles of stone walls in the Town of Philipstown, Putnam County. The table on the following page includes the municipality and the number of markers found by the author. In his search, a big mystery was presented by milestone 42 in Croton-on-Hudson. In 1988, Richard M. Lederer Jr. found it on the east side of the Albany Post Road "about a mile north of the Croton railroad station and protected by fieldstone."[223] It now seems to be missing, so there is one marker that might have been destroyed very recently.

Originally, the markers were placed between the years 1763 and 1769, when Benjamin Franklin was the first postmaster general of the thirteen colonies. They were supposed to be eight feet long, with three feet buried in the ground. Franklin also developed a device for measuring the one-mile distance between the markers. According to James Spratt, "a clacker system was used. A dowel was placed inside a wagon wheel of known circumference or tread length. Each time it made one revolution, it hit a clacker, making a sound that could be counted. If the wheel circumference was say, thirteen feet, it would take 390 revolutions—or clacks—to measure a mile."[224]

In the eighteenth century, the stones were important enough that a 1788 law stated that "the person or persons so removing or willfully breaking, defacing, or in any wise damaging any of the said mile stones, hands, pointers, or any other monument, shall forfeit and pay the sum of three pounds (or) he, she or they so convicted, shall be committed to the common gaol of the county, there to remain without bail or mainprize for the space of thirty days."[225]

Each mile marker was supposed to have been set on the western side of the road so that a traveler could know not only the distance he had traveled by the number on the monument but also the direction that he was headed by the position of the monument. The markers, which have been found by the author recently, were made out of red sandstone south of the Dutchess-Columbia County line and a white stone north of the line.

The author believes that the monuments that he found were not the original ones set in the eighteenth century because the two monuments, which he helped reset and had a chance to measure (milestones 86 and 91), were only in total three feet in length, not the eight feet as specified by Benjamin Franklin. Perhaps they were set later by the Highland Turnpike Company (tolls were charged per mile on the stagecoaches), or perhaps they simply were less expensive replacements for the originals. The one true original is probably the eight-foot-tall mile marker 15 in the basement of the Van Cortlant mansion in the Bronx.

The Van Cortlandt marker was moved inside sometime after 1964 because it was vulnerable outside.[226] It was originally set outside

Carney Rhinevault (left) and Carl Grieco (right).

the mansion after being moved to the site from near King's Bridge.
On November 19, 1934, "[a]t the unveiling of this stone, Reginald
Pelham Bolton, author, historian, and authority on the early history
of Manhattan, stated the milestones [1 through 15] were provided
by the City of New York, and the contractor was George Lindsay, a
stone mason by trade, whose bill was paid by the Common Council in
September 1769. This stone bears the name of John Zunicher, a famous
Dutch stonecutter."[227] Zunicher (or "Zuricher") is famous among the
small number of historians who have studied milestones. "The first
mention of him in the minutes [of the Common Council of the City of
New York] was in March 1754 when he was paid for work done by him

161

CCC "boys" at Staatsburgh preserved many Dutchess County milestones.

on the new Royal Exchange in Broad Street. In 1762 he was paid for cutting twelve cornices and five arches for City Hall."[228]

If nothing else, the author hopes that the stories and illustrations in this book will encourage present and future generations to preserve the small number of milestones listed following. "Though the era of the milestone has passed, the word has become so deeply engrained in our vocabulary that it is now used as a metaphor to describe man's progress."[229]

TABLE 1. MILESTONES FOUND AS OF 2008

Town/City/Village	County	Milestone No.	Total Found
New York City	Manhattan	11, 12, 7 (remains)	2½
New York City	Bronx	15 (in museum)	1

Town/City/Village	County	Milestone No	Total Found
Yonkers	Westchester	19, 20	2
Ardsley-on-Hudson	Westchester	26	1
Irvington	Westchester	27	1
Sleepy Hollow	Westchester	28, 30	2
Ossining	Westchester	36, 31, 35	3
Croton-on-Hudson	Westchester	40	1
Cortlandt	Westchester	43, 44, 46, 50, 51	5
Montrose	Westchester	45	1
Peekskill (city)	Westchester	47, 48, 49	3
Philipstown	Putnam	52–58	7
Cold Spring (village)	Putnam	61	1
Fishkill	Dutchess	66, 69	2
Wappinger	Dutchess	72	1
Poughkeepsie (town)	Dutchess	77, 80, 83	3
Poughkeepsie (city)	Dutchess	82	1
Hyde Park	Dutchess	84–93	10
Rhinebeck	Dutchess	95–101	7
Red Hook	Dutchess	103, 104, 107, 108, 109	5
Livingston	Columbia	114, 116, 118	3
Greenport	Columbia	120	1
Claverack	Columbia	123, 125	2
Kinderhook	Columbia	133, 134, 137	3

Town/City/ Village	County	Milestone No	Total Found
Schodack	Rensselaer	150	1
East Greenbush	Rensselaer	152	1
TOTAL			**70½**

An example of a milestone, no. 16 in Westchester County. *Photo by author.*

Notes

His High Mightiness Is Wearing a Dress!

1. Edward Robb Ellis, *The Epic Of New York City* (Carroll & Graf Publishers, 2001), 110.
2. The fort was renamed Fort William Hendrick for a short time when the Dutch took back the colony from August 1673 to November 1674.
3. Alice Morse Earle, *Colonial Days in Old New York* (Ira J. Friedman, Inc., 1962), 80, 81.
4. Elizabeth D. Levers, *In the Hudson Highlands* (Appalachian Mountain Club, 1945), 238.
5. Evan T. Pritchard, *Native New Yorkers* (Council Oak Books, 2002), 217.
6. Henry Noble MacCracken, *Old Dutchess Forever* (Hastings House, 1956), 82.
7. Stephen Jenkins, *The Greatest Street in the World* (G.P. Putnam's Sons, 1911), 21.
8. There was a second Post Road on the west side of the Hudson River. It began in New Jersey, across from Manhattan, and ended in Albany. Any mail that did not require passage through New York City used this route. There was no need to cross the Hudson River, and a traveler from Albany to Philadelphia or other points south could shave a day off his trip.

9. This *Jersey* should not be confused with another ship with the same name. The second ship was launched in 1736 and is most famous (or, rather, infamous) for being used (when it was in decrepit condition) as a prison ship and slow execution chamber for thousands of unfortunate Continental soldiers who had been captured by the British during the American Revolution.

10. Ormonde DeKay Jr., "His Most Detestable High Mightness," *American Heritage*, 1976.

11. Ibid.

12. One author has come to Cornbury's defense. In a 1998 book, *The Lord Cornbury Scandal*, by Patricia U. Bonomi (University of North Carolina Press), the author contended that Lord Cornbury was more a victim of character assassination than a villain. At the time, in the late seventeenth and early eighteenth centuries, all politics was based on personalities, not political parties or even issues. Backing up her theories with convincing research, she claimed that every one of his supposed crimes was actually more rumor than fact. Governors quickly made enemies out of anybody who did not agree with them. There seemed to be no middle ground. Among his enemies were Reverend Thoroughgood Moore, Elias Neau, Reverend John Brooke, George Clarke, Thomas Byerly, navy captains Fane and Richard Davis, army captain James Weemes and private citizens Robert Livingston in New York and Lewis Morris and Samuel Jennings in New Jersey. The massacre of Cornbury's reputation may have been started by the innocent widow of General Richard Montgomery. Janet Livingston Montgomery, who was related to the previously mentioned Robert Livingston and who was born forty years after Lord Cornbury's term as governor, wrote this about Cornbury's wife: "The lady of this very just nobleman was equally a character. He had fallen in love with her ear, which was very beautiful. The ear ceased to please and he treated her with neglect. Her pin-money was withheld and she had no resource but begging and stealing. She borrowed gowns and coats and never returned them. As hers was the only carriage in the city, the rolling of the wheels was easily distinguished, and then the cry in the house was 'There comes my lady; hide this, hide that, take that away.' Whatever she admired in her visit she was sure to send for next day.

She had a fancy to have with her eight or ten young ladies, and make them do her sewing work, for who could refuse their daughters to my lady." One can only surmise that this bit of scandal was handed down to Janet by her Livingston parents or grandparents. Her memories were written in a small notebook (now in the possession of the archives of Historic Hudson Valley in Sleepy Hollow, New York) during her old age. The notebook was quoted by Alice Morse Earle in 1896 (published in 1962), and since that time, several historians have embellished the legend. This author hopes that he has been fair to those historians and to Lord Cornbury (may he rest in peace).

13. DeKay, "His Most Detestable High Mightness."

14. Ibid.

15. Alf Evers, *The Catskills From Wilderness to Woodstock* (Doubleday & Company, 1972).

16. Carl Carmer, *The Hudson* (Grosset & Dunlop, 1968).

17. Ronald W. Howard, *The Empire State*, ed. Milton M. Klein (Cornell University Press, 2001), 138.

18. Arthur Bartlett Maurice, *Magical City* (New York: Charles Scribner's Sons), 1935, 110.

PRENDERGAST'S ARMY AND THE WILD RIDE ON THE POST ROAD THAT SAVED ITS LEADER

19. The Prendergast farm actually belonged to Frederick Philipse III, Beverley Robinson, Adolph Philipse (he died in 1750, and the power of attorney was held by John Ogilsie) and Roger Morris (all of whom signed a deed over to Prendergast in 1774).

20. Carmer, *The Hudson*, 66.

21. Now the east yard of Locust Grove, the former Samuel F.B. Morse mansion.

22. Frank Hasbrouck, *The History of Dutchess County* (S.A. Matthieu, 1909), 91.

23. MacCracken, *Old Dutchess Forever* (quote from 1766 *Weekly Post Boy*).

24. Irving Mark, *Agrarian Conflicts in Colonial New York* (Columbia University Press, 1940), 147.

25. Quoted from the 1766 *New York Gazette* by the *Poughkeepsie Journal*, July 4, 1989, 13A.

26. Ibid.

27. Carl Carmer, *For the Rights of Men* (Hinds, Hayden & Eldredge, 1947), 16.

28. Reverend Conway P. Wing, *John Wing of Sandwich, Mass. and His Descendents* (DeVinne Press, 1888). A copy of this rare book is in the genealogy room of the Adriance Library, Poughkeepsie, New York.

29. Edmund Platt, *History of Poughkeepsie* (Platt & Platt, 1905), 27.

30. The deed is filed in Liber 82, page 176, in the Dutchess County Clerk's Office in Poughkeepsie. Prendergast paid £135 (a fair price at the time) for his farm. The deed is described in simple terms, such as "the southeast corner at a heap of stones," "sixteen links from a walnut sapling marked near the foot of a hill," "south of the road," "a stone set in the ground in a lane" (which must have been hard to find after it tripped up a few horses and people and was probably removed) and "a heap of stones north of a small brook." According to the 1944 *Dutchess County Historical Society Yearbook*, "The home was where the Pawling Golf Links are now."

31. Louise Tompkins, *Dutchess County Historical Society Yearbook*, vol. 57, 1972, 54.

REVOLUTIONARY WAR SPIES ON THE POST ROAD

32. "Lieutenant General Burgoyne ['Gentleman Johnny,' 1722–1792] was an illegitimate son of Lord Bingley. He entered the army at an early age, and his education and the influence of his father soon placed him in the line of promotion…He was elected to a seat in Parliament as representative for Preston, in Lancashire. He came over to America in 1775, and was at Boston at the time of the battle of Bunker Hill. He was sent to Canada the same year, but early in 1776 returned to England. Through the influence of the king and Lord George Germain, he was appointed to the command of the northern British army in America in the spring of 1777. After some successes, he was captured, with all his army, at Saratoga, in October of that year…He

died of an attack of gout, on the 4th of August, 1792." Taken from *The Pictorial Field-book of the Revolution* by Benson J. Lossing.

33. The Hendriksen Tavern later became the Forbus House and, still later, the Nelson House. President Franklin Delano Roosevelt gave many speeches in the Nelson House ballroom during political campaigns in the 1920s, 1930s and 1940s. A county office building now occupies the spot.

34. John Bakeless, *Turncoats, Traitors and Heroes* (J.B Lippincott Company, 1959).

35. The silver ball and letter are now in a museum at Fort Ticonderoga.

36. A few people in Kinderhook were reminded of Burgoyne's march as late as 1942. The story begins like this: Burgoyne, his two aides and several Continental guards were invited to spend the night at the home of David Van Schaack in the hamlet, while the other 5,500 British and Hessian prisoners encamped in the woods and fields surrounding Kinderhook. Toasts were drunk to "Gentleman Johnny" Burgoyne, General Washington and others. Probably in the spirit of the moment, the Van Schaack daughter also offered a toast to "His Majesty the King and all the Royal family." The dismay of the American soldiers at this effrontery must have been overwhelming. Eventually, however, this incident was forgotten at the Van Schaack house until 1942. Early 1942 was a time of great distress in Kinderhook. The Americans had entered World War II, the Japanese were winning battle after battle in the Pacific and Nazis had overrun all of Europe. Ten Kinderhook residents had just had dinner in the Van Schaack house. The *Chatham Courier* related the story from that moment: "After dinner the 10 filtered out of the dining room and settled down before the fireplace where coffee was served. Then, and without warning, a light breeze seemed to stir through the room as if a window or door had been opened suddenly. One of the guests, a young woman, looked at the expanse of wall above the fireplace and pointed. She was so overcome with fear that she uttered not a word. Everyone's eyes followed her finger and there, clear and distinct, was the shadowed outline of an American soldier of the Revolution. Slowly, with musket in hand, he seemed to march across the wall and disappear into the darkness. Awe-stricken, the guests sat silently, trying to account for what they had seen. Was it

the spirit of one of the American officers who had been in that same room on an October night in 1777? Someone recalled the old adage that patriots could not sleep in their grave when the nation was in peril. Were the ghosts of the Revolution marching that night to the side of their beloved America during its moment of anguish? Yet those who were in the Van Schaack homestead that night will never forget the shadow on the wall. Possibly the patriots did march, for only a year later MacArthur began his offensive toward Japan while a giant arsenal was growing in England for the eventual landings in Normandy. Who can tell?"

37. Russell Potter Reeder Jr., *The Story of the Revolutionary War* (Duell, Sloan, and Pearce, 1959).

38. Apparently, more than words of encouragement were offered to the Hessian soldiers. Some of the German soldiers hadn't had a conversation with a woman in years. The local Kinderhook girls would have seemed mighty nice. Several Hessian soldiers deserted their commands and started families, and some of their descendants remain in the area today. One soldier attempted to describe, in general terms, the "dozens of girls we met along the Albany Post Road." He said, "The ladies in this vicinity [Kinderhook] are slender, of erect carriage, and, without being very strong, are plump. They have small and pretty feet, good hands and arms, a very white skin and a healthy color in the face, which requires no other embellishment. They have also exceedingly white teeth, pretty lips, and laughing sparkling eyes. They are great admirers of cleanliness and keep themselves well shod." Of the 5,500 soldiers captured, roughly half of them had deserted by the end of the war. One British officer complained that his servant ran from him with everything he could take. This author believes that he is descended from one of the Hessian soldiers, Wilhelm Reinwold, who later changed his name to William Rhinevault, switched sides to fight with the Americans and earned a pension from the United States government.

39. Alexander J. Wall, *Narratives of the Revolution in New York* (New York: New York Historical Society, 1975).

Nathaniel Pendleton

40. Mary Hertz Scarbrough, *The Battle of Harlem Heights* (Blackbirch Press, 2004), 21.

41. Barnet Schecter, *The Battle for New York* (Walker and Company, 2002).

42. Dr. John Bard (1730–1799) was one of the few prominent men in colonial New York who was able to maintain his political neutrality at the time of the American Revolution. He and his family lived in New York City during the British occupation and doctored Americans and British alike. After the war, he and his son, Samuel, became President Washington's personal physicians.

43. According to Benson J. Lossing in his *Pictorial Field-Book of the Revolution*, published by Harper and Brothers in 1855, "Nathanael Greene was born of Quaker parents, at Warwick, in Rhode Island, in 1740. His father was an anchor smith, and in that business Nathanael was trained. While yet a boy, he learned the Latin language, and by prudence and perseverance he collected a small library while a minor. The perusal of military history occupied much of his attention. He had just attained his majority, when his abilities were so estimated, that he was chosen a representative in the Legislature of Rhode Island. Fired with military zeal, and ardent patriotism, young Greene resolved to take up arms for his country, when he heard of the battle at Lexington. He was appointed command of three regiments in the Army of Observation, raised by his state, and led them to Roxbury. In consequence of this violation of their discipline, the Quakers disowned him. General Washington soon perceived his worth, and in August the following year, Congress promoted him from the office of brigadier of his state militia to that of major general in the Continental army. He was in the battles at Trenton, Princeton, Brandywine, Germantown, Monmouth, Camden, and Guilford." He served as second in command to General Washington and was placed in command of the entire Continental army at times when Washington was away from his post.

44. Theodore Thayer, *Nathanael Greene, Strategist of the American Revolution* (Twayne Publishers, 1960).

45. Saint James Parish, *Historical Notes* (A.V. Haight Company, 1913), 36.

46. Francis Vinton Greene, *General Greene* (D. Appleton and Company, 1897), 312.

47. John F. Stegeman and Janet A. Stegeman, *Caty: A Biography of Catherine Littlefield Greene* (Rhode Island Bicentennial Foundation, 1977), 148.

48. Ibid., 144.

49. No painting of this mansion, which was located on the southwesterly corner of West Bay and Barnard Streets, could be found after a search by the Georgia Historical Society. The building, which was the site of the funeral of General Nathanael Greene after he died of a sunstroke, has long sense disappeared.

50. Stegeman, *Caty*, 118.

51. Saint James Parish, *Historical Notes*, 36.

52. "Alexander Hamilton was born on the island of Nevis, British West Indies, on Jan. 11, 1757. He was of Scottish descent by his father; French by his mother. He received a fair education, and in 1769 became a clerk to Nicholas Cruger, a merchant of St. Croix. Later he was placed in a grammar school in New Jersey, under the tuition of Francis Barber, who afterward became a distinguished officer of the Revolution. He entered King's [Columbia] College in 1773, and at the age of seventeen appeared as a speaker at public meetings. As an artillery captain in the Revolution, he fought at White Plains, Trenton, Princeton, and Yorktown. In 1782, he was admitted to practice law in New York and later became a member of Congress. His great financial knowledge caused Washington to choose him for his first Secretary of the Treasury, and he was very useful to the president during his whole administration. The American republic never had a truer friend or abler supporter than Alexander Hamilton." Taken from Lossing's *Pictorial Field-Book of the Revolution*.

53. Matthew L. Davis, *Memories of Aaron Burr*, vol. 2 (DeCapo Press, 1971), 329.

54. July 26, 1804 letter, Bard family papers, Bard College; Barrytown, New York.

55. After Pendleton's death, his family held the Placentia mansion until 1845, when it was sold to James Kirke Paulding. Paulding was a friend and literary associate of Washington Irving and also a good friend of former President Martin Van Buren, who lived forty-five miles up the

Post Road in Kinderhook. From 1838 to 1841, he served as secretary of the navy. Like Washington Irving, he was a gifted humorist. In a letter to Van Buren, he wrote about Placentia: "We sowed a field of oats, some time ago, it came up the very next morning…I think of floating You up a Small Raft of Asparagus by Water, as it is too large to go up the Post Road, and I could realize a great profit in it, if it would only make good Boards and Plank. As to our Sallad, You will be I presume not a little envious, when you learn, that when Lazzy Hopper, our Factotum, went to gather some for dinner the other day, he found two of his children, snugly ensconced, among the leaves of one of the heads, where they had sheltered themselves from the rain." Paulding also wrote the famous tongue twister, "Peter Piper picked a peck of pickled peppers." Placentia burned to the ground on October 19, 1900, possibly the target of a serial arsonist. Other mansions that burned down during the same time period were the Belvedere Mansion in Staatsburgh in 1899 and the Drayton Mansion, half a mile south of Placentia, also in 1899. Mrs. Irmgard Apfel, the current owner of the property, graciously gave a tour of the site to the author. One of the bricks from the mansion that were scattered around the site is now in the author's collection of historical oddities.

56. Benson Lossing, *The Hudson: From the Wilderness to the Sea* (1866), 185.

57. The Saint James Episcopal Church in the 1930s and 1940s was known as the "President's Church" because President Franklin Roosevelt and Eleanor Roosevelt often attended services there. On a Sunday morning in June 1939, it was the scene of an event that would have been impossible during Pendleton's lifetime: the king and queen of England, along with the Roosevelts, attended services there. All traffic on the Post Road and West Market Street was stopped for hours while throngs of Hyde Park well-wishers stood on the stone walls along the streets to catch a glimpse of the king and queen.

58. James A. Braman (J.A.B.), box 3, "Anecdotes," 1876, notes, 42, Franklin D. Roosevelt Library Archives.

59. Pendleton's only daughter, Anna Pierce Pendleton (1796–1883), later in her life owned a house at 6 Main Street, Hyde Park. It is now the home of the author and illustrator. Conspicuous in its absence is a sketch of Nathaniel Pendleton himself. Every attempt was made by the

author to obtain one, but none of the living descendants of Pendleton could find one. The only known image of Pendleton is the fictional painting of him on page 37, in which he is standing next to Hamilton during the famous duel.

60. Edward Braman, "Genealogy and History of Hyde Park Families" (unpublished, 1875), 34, note 3. Milestone 84 is situated on almost the exact spot where Pendleton died.

Citizen Genet of East Greenbush

61. George Baker Anderson, *Landmarks of Rensselaer County* (D. Mason & Company, 1897), 355.
62. Ray A. Mowers, *Albany Evening News*, April 19, 1937.
63. Harry Ammon, *The Genet Mission* (Norton & Company, 1973).
64. East Greenbush Sesquicentennial Committee, *Yesterday and Today* (self-published, 2005), 5. The Government House was built on the original site of the colonial fort at the tip of Manhattan.
65. John P. Kaminski, *George Clinton: Yeoman Politician of the New Republic* (Madison House, 1993), 240.
66. Edwin G. Burrows and Mike Wallace, *Gotham* (Oxford University Press, 1999), 318.
67. Richard B. Morris, "The Trials of Chief Justice Jay," *American Heritage*, 1969, 86.
68. The state government had moved from New York City to Albany in 1797.
69. Quoted by Bob Shillinglaw, *Greenbush Area News*, April 2, 1975.
70. Richard S. Allen, *Knickerbocker News Union-Star*, September 7, 1971.
71. Elisha Jenkins was state comptroller (1801–6), secretary of state (1806–13), mayor of Albany (1816–19) and a member of the Board of Regents.
72. John Tayler, a cousin of DeWitt Clinton and a state senator from 1807 until 1813, became lieutenant and acting governor in 1817.
73. Dr. Charles Cooper was Albany County clerk and husband of Tayler's niece. It is difficult to imagine a doctor who could administer such a wanton beating.

74. Francis Bloodgood was clerk of both the state Supreme Court and the Board of Regents.

75. Cornelius Schermerhorn, an innkeeper, was a witness only.

76. Bob Shillinglaw, *Troy Times Record*, May 19, 1973.

77. Ibid.

78. Ammon, *Genet Mission*, 176.

79. The Erie Canal's biggest promoter was Dewitt Clinton, Genet's brother-in-law. It was called "Clinton's big ditch" by its detractors but proved to be a tremendous success.

80. An 1825 first edition of this book, in good condition, is worth $6,500 at book auctions.

81. Bob Shillinglaw, *Greenbush Area News*, February 14 & 21, 1974.

82. Ibid.

83. Richard S. Allen, *Knickerbocker News Union-Star*, September 8, 1971.

84. Tyler Anbinder, *Five Points* (Plume, 2002), 332.

85. Edwin W. Morse, *The Vanguard of American Volunteers* (New York: Scribners, 1918).

War of 1812 Cantonment Greenbush

86. One of the officers' quarters buildings is still being used as a multiple-family dwelling and is maintained in good condition.

87. Samuel Wilson's grave in Oakwood Cemetery in Troy has become a minor tourist attraction. Signs on New York State Route 7 direct visitors to the burial site of "Uncle Sam."

The President Who Wasn't Great, Just "OK"

88. "According to local legend, [William P.] Van Ness gave Burr refuge in a secret sealed room at Lindenwald after he killed Hamilton." Frank L. Amoruso, *The Village of Kinderhook, 1609–1976* (Village of Kinderhook, 1976).

89. The nickname "Talleyrand" meant different things to different people. Charles Maurice de Talleyrand-Perigord (1754–1838) was a

French diplomat in the early nineteenth century. To some people, he was known as a statesman of great resource and skill, but to others, he was a bribe accepter and crook. He nearly brought on a major conflict between the United States and France by asking for a $250,000 bribe (known as the XYZ Affair).

90. Quote from *The Town of Clermont* (Hudson Press, 1928), 137–38 (courtesy of Ms. Anne Poleschner, Clermont town historian).

91. People must have wondered how Martin Van Buren and Henry Clay could have been such good friends. Van Buren had been nominated or tried for the nomination for president four times, and Clay had been nominated or tried for the nomination five times. Three of those attempts were in the same year as Van Buren—in 1840, 1844 and 1848. Clay was known as the "Great Compromiser" and author of the Fugitive Slave Act of 1850. He died in 1852.

92. John Ward Cooney, *My Recollections of Ex-President Martin Van Buren* (Missoula, MT), courtesy of Calvin S. Pitcher, Ghent town historian.

93. Militia Brigadier General William Paulding Jr. (1770–1854) served in the War of 1812. He was a former New York City mayor (1824–26) and U.S. congressman (1811–13). He also was the immediate northerly neighbor to Washington Irving in Tarrytown, New York, and probably traveled the Post Road with Irving to visit the ex-president.

94. Quote from *The Van Buren Chronicles*, courtesy of Calvin S. Pitcher.

95. Carmer, *The Hudson*, 309, 310.

96. Amoruso, *Village of Kinderhook*.

Anti-Rent Wars in Columbia County, 1751–1852

97. Mark, *Agrarian Conflicts in Colonial New York*.

98. G.D. Scull, ed., *The Montresor Journals* (New York, 1882).

99. Joan Gordon, "Kinship and Class: The Livingstons of New York, 1675–1860," doctoral dissertation, Columbia University, 1959.

100. Carmer, *The Hudson*, 81.

101. William Strickland, an aristocrat from England, compiled a journal of his travels in America in 1794–95. He wrote that for breakfast at

Livingston manor they "had scraped beef, ham, red herrings, cold meat, and other relishes, which are here great favourites in the morning, upon the same table and what at some seasons of the year must be a great luxury. The butter was laid upon a piece of transparent ice, and covered with other similar pieces to keep it cool and hard. Four Negro boys, the eldest about 11 or 12, the youngest about 5 or 6 years old, clean and well dressed but bare-footed, in a livery green turned up with red waited about the table." Strickland was also impressed with supper, a meal of wild game followed by "pastry and confectionery of great variety and excellence." Also served were "melons, apples, peaches, and several sort of nuts."

102. *Columbia County at the End of the Century* (published by the *Hudson Gazette*, 1900).

103. Staughton Lynd, *Narratives of the Revolution in New York* (New York: New York Historical Society, 1975).

104. Barnet Schecter, *The Battle for New York* (Walker and Company, 2002).

105. Joseph E. Persico, "Feudal Lords on Yankee Soil," *American Heritage*, October 1974.

106. *The History of Columbia County* (Everts and Ensign, 1878).

107. Carmer, *The Hudson*, 294.

108. See *The History of Columbia County*.

109. See *The History of Columbia County*. General John Watts de Peyster (1821–1907) was the loser in this important court case. He had married a Livingston daughter, Estelle Livingston, in 1841. His claim to the title "General" may have been fraudulent because no record of his military career has been found other than one reference to him having served in a militia. His claim to manorial rights was also weak because they were based solely on marriage. After losing the court case, he became extremely eccentric and bitter. He harbored resentment against "Big Thunder" and the legal profession for sixty years, dying in 1907. However, he has remained somewhat a folk hero in the stories told by people in Tivoli, New York. It is said that De Peyster "was a fireman in New York City while he attended Columbia College in the 1840s. He was sent to Europe, where he studied foreign military systems and also used the opportunity to study European firefighting methods. Upon his return, he advocated national firefighting reforms that were

adopted by the New York City Fire Department." The old Tivoli fire station was given to the village by De Peyster, along with several other buildings (the old village hall and library, the Methodist church and the Leake and Watts Children's Home).

110. An interesting story about tenancy still exists even today in the village of Rhinebeck. According to Nancy V. Kelly, in her book *A Brief History of Rhinebeck* (Wise Family Trust, 2001), "[T]hose owning homes on church land pay an annual quit rent of about $10 to the Dutch Reformed Church, in keeping with a stipulation by Henry Beekman from more than two centuries ago."

A Long Night in Poughkeepsie

111. *Journal and Poughkeepsie Eagle*, February 2, 1850.
112. Jenkins, *Greatest Street in the World*, 425.

Underground Railroad Stations along the Post Road

113. Roberta Singer, "Slaveholding on Livingston Manor and Clermont, 1686–1800," *Dutchess County Historical Society Yearbook*, 1984.
114. On May 21, 1796, fifteen slave owners in the Hudson Valley formed the "Slave Apprehending Society." The following is a copy of a document found in the New York State Library Archives in Albany, New York: "Whereas a suspicion seems to prevail among many of the Negro Slaves that the Legislature of the State has liberated them and that they are now held in servitude by the Arbitrary power of their Masters contrary to law and their uneasinefs and disquietude on this Subject most certainly incresfes by the insidious suggestions of some Mischevious Whites who secretly encourage them to Run away, Being operated upon by such influence it appears that a Number of them have undertaken an escape from their Masters, for prevention and Remedy whereof. The Object of the Society shall be to detect and prevent Run away Slaves escaping from their Masters and also to

detect and bring to legal punishment such Whites or free Negroes as may transgress the laws respecting Slaves."

115. Henry Steele Commager, ed., *The Civil War* (Promontory Press, 1976), 66.

116. Tom Calarco, *The Underground Railroad Conductor* (2003).

117. Anbinder, *Five Points*.

118. According to Benson Lossing in his book *The Hudson: From the Wilderness to the Sea*: "The Livingston mansion is preserved in its original form, under its roof, in past times, many distinguished men have been sheltered. Washington had his headquarters there towards the close of the revolution, and there, in November, 1783, Washington, George Clinton, the civil governor of the State of New York, and Sir Guy Carleton, the British commander, met to confer on the subject of prisoners, the loyalists, and the evacuation of the city of New York by the British forces. The former came down the river from Newburg, with their suites, in barges, the latter, with his suite, came up from New York in a frigate. Four companies of American light infantry performed the duties of a guard of honour on that occasion." The grand wooden structure, which was the heart of the Livingston manor since 1698, was lost to a spectacular fire on September 1, 1974. It was located at the present-day corner of Broadway (the Post Road) and Livingston Avenue.

119. The black community in Peekskill would like to create an Underground Railroad Museum in this house. Calarco, *Underground Railroad Conductor*.

120. No evidence of the once thriving community of Baxtertown remains today—no stone foundations nor descendants of the original black settlers. However, there are at least two headstones in the small cemetery a short distance north on Osborn Hill Road that mark the burial location of former slaves.

121. *Poughkeepsie Journal*, February 21, 1993.

122. Roger A. King, *The Underground Railroad in Orange County, N.Y.: The Silent Rebellion* (1999).

123. Lawrence H. Mamiya and Lorraine M. Roberts, "Invisible People," *Dutchess County Historical Society Yearbook*, 1987.

124. A mutual aid group met from 1837 to 1844 in the Lancaster School on Church Street, one block east of the Post Road (many years later

called Germania Hall). This would have been a perfect building to hide fugitives.

125. *Dutchess County Historical Society Yearbook*, "John A. Bolding, Fugitive Slave," 1935.

126. Matthew Vassar's nephew, Matthew Vassar Jr., had different sympathies. He and his employees at the Vassar Brewery were known to break up meetings of abolitionists. This was probably done to please his beer and ale customers in the South.

127. It is very possible, however, that the subbasement was used as a wine cellar.

128. The Bergh Tavern is now a sushi restaurant.

129. A recent archaeological dig at the Guinea community (now the town-owned Hackett Hill Park) revealed several items that the former residents used.

Samuel F.B. Morse

130. Marshall B. Davidson, "What Samuel Wrought," *American Heritage*, April 1961, 15.

131. Ray Allen Billington, "The Know-Nothing Uproar," *American Heritage*, February 1959, 58–59.

132. Edwin G. Burrows and Mike Wallace, *Gotham* (Oxford University Press, 1999), 545.

133. Davidson, "What Samuel Wrought," 106.

134. In 1842, Morse tried running an underwater cable from Castle Garden at the southern tip of Manhattan to Governors Island (about half a mile) and attempted to demonstrate his telegraph. According to Burrows and Wallace in their book, *Gotham*, "The receiver worked for a bit, then died when the wire snagged on a departing ship's anchor and was hauled up and sliced apart by puzzled sailors. The crowd, believing itself hoaxed, dispersed with jeers," 675.

135. Davidson, "What Samuel Wrought," 110.

136. Michael Blow, "Professor Henry and His Philosophical Toys," *American Heritage*, December 1963, 105.

137. Davidson, "What Samuel Wrought," 111.

138. Blow, "Professor Henry and His Philosophical Toys," 105.

139. Carleton Mabee, *The American Leonardo* (New York: Alfred A. Knopf, 1943), 244.

140. *Philadelphia Dollar Newspaper*, July 25, 1855; *Photographic Art Journal*, September 1855.

141. D. Jay Culver, "The Camera Opens Its Eye on America," *American Heritage*, December 1956, 50.

142. Peter Pollack, *The Picture History of Photography* (Harry N. Abrams, Inc., 1977), 56–59.

143. Kenneth Silverman, *Lightning Man* (New York: Alfred A. Knopf, 2003), 379.

144. Mabee, *American Leonardo*, 377.

The Smith Brothers of Poughkeepsie

145. Jenkins, *Greatest Street in the World*, 24.

146. Kaminski, *George Clinton*, 165.

147. If you visit Alex's, be sure to try their goulash on Tuesday or maybe Karen's chicken pita. The author is a regular customer.

148. The Forbus House (1807–76) was later operated as the Nelson House (1877–1940s). It was the scene of many of President Franklin Delano Roosevelt's political rallies.

149. Gerald Carson, "The Beards That Made Poughkeepsie Famous," *American Heritage*, December 1972, 23.

150. Frederick A. Smith, "The Smith Brothers—'Trade' and 'Mark,'" *Dutchess County Historical Society Yearbook*, 1947, 86.

151. *Poughkeepsie New Yorker*, August 16, 1944.

152. One minor item that certainly never appeared in the Smith brothers' advertising involved the lot next door to the Smith Brothers Restaurant, the corner lot, which is now the site of Alex's Restaurant. Philip H. Smith, in his book *General History of Duchess County*, related the following: "A deed of land was given in 1718, for the use of the inhabitants of Poughkeepsie for a burial place, and plot for a meeting-house, wherein the worship of God was conducted in the Low Dutch language…The ground deeded was on the corner of Main and Market Streets. The

older inhabitants will remember the mean old buildings which covered that ground until the year 1830, beneath which were the remains, thickly planted, of the earlier people of Poughkeepsie. In that year these remains were removed, and the fine buildings that now cover the front of the ground were erected. The late Gilbert Brewster built several of them, and that corner of Main and Market Street was long known as 'Brewster's Corner.' The entire plot was devoted to burials. As the city grew this ground was wanted for building lots. At first the desecration was permitted so far as to allow the inhabitants to put buildings upon the ground, but were not allowed to have any cellars under them. In a little while, human bones began to appear about the streets, and around the dumping grounds—the people being inclined to transcend their privileges somewhat, some excavating underneath their houses unobserved. Finally the ground was dug over, the bones carefully picked out, and placed in a vault in the rear of the Smith Brothers restaurant." The Smith Brothers Restaurant is long gone, but the building is still in the same location. In the cellar near the back is a bricked-over section that is inaccessible. The maintenance man for the building claims that at night he has seen inanimate objects fly off the shelves. Could the bones still be there, and could ghosts be searching for their material remains?

Gypsies on the Post Road

153. It would be impossible for any gypsies to live in a peaceful campsite at Nepperhan today. The noisy Saw Mill River Parkway now cuts through the area. Nepperhan also has some historical significance. The hills surrounding the quiet little valley (once known as the "Vale of Yonkers") were the scene in August 1781 of one of the best deceptions perpetrated by the American military. In order to meet up with General Lafayette and our French allies at Yorktown, Washington left General Heath and 2,500 men to make fake military movements, campfires and other fake preparations for an attack on Manhattan. The British took the bait and stayed in their fortifications on the island instead of chasing down Washington's forces. The great American victory at the Battle of Yorktown was the result.

154. *New York Times*, July 16, 1889.
155. Bea Fredriksen, *Dutchess Suburban Newspapers*, June 1974.
156. *New York Times*, August 7, 1902.
157. *New York Times*, April 17, 1888.

YOUNG FDR AND THE GILDED AGE AT HYDE PARK

158. The land of the Vanderbilt estate had an impressive history for two hundred years before the Vanderbilt ownership. The land was originally granted to Peter Fauconnier, secretary to Edward Hyde, Lord Cornbury, governor of New York, in 1705. Dr. John Bard, who had married Fauconnier's granddaughter, purchased the estate in 1746. Bard's claim to fame was that he was the personal physician to George Washington and saved Washington's life early in his first administration by removing a large abscess on the president's leg. The estate became known as Hyde Park during his ownership about one hundred years before the town acquired the name. After John Bard's death in 1799, his son, Dr. Samuel Bard, took over ownership and made extensive horticultural improvements and built a large mansion in the same spot where the Vanderbilt mansion now stands. Upon Samuel Bard's death in 1821, the estate passed to his son, William Bard, who sold the property to Dr. David Hosack in 1828. Dr. Hosack was the attending physician at the famous Alexander Hamilton–Aaron Burr duel. After his death in 1835, his estate was sold to John Jacob Astor, who in turn gave it to his daughter, Dorothea Astor Langdon. In 1853, her son, Walter Langdon Jr., inherited the property and owned it until his death in 1894, when the Vanderbilts purchased it. The huge mansion was then torn down, and an even bigger one (the one that is visited now by thousands of people each year) was built. During Dr. Hosack's tenure at the estate, he was visited by a citizen of Great Britain, Harriet Martineau, in 1835. Following are excerpts from her story: "The aspect of Hyde Park from the river had disappointed me, after all I had heard of it. It looks little more than a white house upon a ridge. I was therefore doubly delighted when I found what this ridge really was. It is a natural terrace, overhanging one of the sweetest

reaches of the river; and, though broad and straight at the top, not square and formal, like an artificial embankment, but undulating, sloping, and sweeping between the ridge and the river, and dropped with trees; the whole carpeted with turf, tempting grown people, who happen to have the spirits of children, to run up and down the slopes, and play hide-and-seek in the hollows. Whatever we might be talking of as we paced the terrace, I felt a perpetual inclination to start off for play. Yet, when the ladies and ourselves actually did something like it, threading the little thickets and rounding every promontory, even to the farthest (which they call Cape Horn), I felt that the possession of such a place ought to make a man devout if any of the gifts of Providence can do so. To hold in one's hand that which melts all strangers' hearts is to be a steward in a very serious sense of the term. Most liberally did Dr. Hosack dispense the means of enjoyment he possessed. Hospitality is inseparably connected with his name in the minds of all who ever heard of it; and it was hospitality of the heartiest and most gladsome kind. Dr. Hosack had a good library; I believe, one of the best private libraries in the country; some good pictures, and botanical and mineralogical cabinets of value. Among the ornaments of his house I observed some biscuits and vases once belong to Louis XVI, purchased by Dr. Hosack from a gentleman who had them committed to his keeping during the troubles of the first French Revolution [this "gentleman" was probably Citizen Edmond Charles Genet, who lived up the Post Road in East Greenbush]. In the afternoon Dr. Hosack drove me in his gig round his estate, which lies on both sides of the high [Post] road; the farm on one side and the pleasure-grounds on the other. The conservatory is remarkable for America; and the flower-garden all that it can be under present circumstances, but the neighboring country people have no idea of a gentleman's pleasure in his garden, and of respecting it. On occasions of weddings and other festivities, the villagers come up into the Hyde Park grounds to enjoy themselves; and persons who would not dream of any other mode of theft, pull up rare plants, as they would wild flowers in the woods, and carry them away. Dr. Hosack would frequently see some flower that he had brought with much pains from Europe flourishing in some garden of the village below. As soon as he explained the nature of the case, the plant would be restored

with all zeal and care; but the losses were so frequent and provoking as greatly to moderate his horticultural enthusiasm. We passed through the poultry-yard, where the congregation of fowls exceeded in number and bustle any that I had ever seen. We drove round his kitchen-garden too, where he had taken pains to grow every kind of vegetable which will flourish in that climate. Then crossing the [Post] road, after paying our respects to his dairy of fine cows, we drove through the orchard, and round Cape Horn, and refreshed ourselves with the sweet river views on our way home. There we sat in the pavilion, and he told me much of DeWitt Clinton, and showed me his own Life of Clinton, a copy of which he said should await me on my return to New-York. When that time came he was no more; but his promise was kindly borne in mind by his lady, from whose hands I received the valued legacy. We saw some pleasant society at Hyde Park; among the rest, some members of the wide-spreading Livingston family, and the Rev. Charles Stewart, who lived for some years as missionary in the South Sea Islands, and afterward published a very interesting account of his residence there."

159. Charles W. Snell, *Vanderbilt Mansion* (Washington, D.C.: National Park Service, United States Department of the Interior, 1960).

160. Rocco C. Andros, *Memories of Hyde Park, New York* (Town of Hyde Park Historical Society, 2006), 18.

161. Carney Rhinevault, *Colonel Archibald Rogers and the Crumwold Estate* (Peter Vermeer Rhinevault Scholarship Fund, 2003), 37.

162. Ted Morgan, *FDR: A Biography* (New York: Simon and Schuster, 1985).

163. Russell Freedman, *Franklin Delano Roosevelt* (Scholastic Inc., 1994).

164. Andros, *Memories of Hyde Park*, 17.

165. Olin Dows, *Franklin Roosevelt at Hyde Park* (American Artists Group, n.d.).

166. Wayne Andrews, *The Vanderbilt Legend* (Harcourt, Brace and Company, 1941).

167. William P. Stephens, *Traditions and Memories of American Yachting* (Wooden Boat Publications, 1989).

168. Morgan, *FDR*.

169. Henry Noble MacCracken, *Blithe Dutchess* (Hastings House, 1958).

170. Rhinevault, *Colonel Archibald Rogers*, 37.

171. Snell, *Vanderbilt Mansion*.

172. Rhinevault, *Colonel Archibald Rogers*, 19.

173. Joseph W. Emsley, *Poughkeepsie Star-Enterprise*, January 9, 1937.

174. Morgan, *FDR*.

175. Rhinevault, *Colonel Archibald Rogers*, 51.

176. Sara Roosevelt, *My Boy Franklin* (1933).

177. Emsley, *Poughkeepsie Star-Enterprise*, January 9, 1937.

The Rise and Fall of Woodcliff Pleasure Park

178. Dumas Malone, ed., *Dictionary of American Biography*, vol. 10 (New York: Scribner's, 1936), 399.

179. The dock is long gone, but steps leading up from the river can still be found today.

180. Francis Brown Wheeler, *John Flack Winslow and the Monitor* (privately printed, 1893).

181. *Poughkeepsie Sunday New Yorker*, August 20, 1944.

182. Letter written by Harriet Winslow Wheeler (Winslow's granddaughter), January 1987, Adriance Library, Poughkeepsie, New York.

183. Article from a newspaper, publication and date unknown.

184. *Poughkeepsie Sunday New Yorker*, August 20, 1944.

185. Article from a newspaper, publication and date unknown.

186. Wheeler letter, January 1987.

187. Joyce C. Ghee and Joan Spence, *Poughkeepsie: Halfway up the Hudson* (Arcadia Publishing, 1997), 77.

188. Roger Romano, *The Circle* (Marist College student newspaper), vol. 28, no. 19, April 28, 1983.

189. The gatehouse was actually removed during the widening of the Albany Post Road in 1962. It had become a landmark itself. The "Little Pink House" was saved shortly before the highway construction crews arrived. It was carefully disassembled, bit by bit, and numbered so that it could be rebuilt at the Boscobel property in Garrison, New York, by an ardent environmentalist, Benjamin Frazier. Sometime in the 1970s, the building burned down (after all of that hard work), and the last relics of Woodcliff Park went up in smoke.

190. Personal interview with Robert Arata, Hyde Park, August 18, 2008.

191. Ibid.

192. On June 23, 1987, former sheriff Quinlan wrote a letter to the editor of the *Poughkeepsie Journal* and stated, "I received a knife wound when my back was turned in an area where it was difficult to sit down for a while."

193. *Poughkeepsie Eagle News*, August 11, 1941.

194. Wheeler letter, January 1987.

The Unsolved Murder of Surveyor Frank L. Teal

195. Deborah Dows, unpublished short story, Frank L. Teal papers, 1935, Egbert Benson Historical Society.

196. Helen Chapman, "Who Killed Frank Teal?" *Barrytown Explorer*, July 27, 1959.

197. Unfortunately, Teal's transit has been lost. It would certainly have been an interesting historical antique. It was probably an old five-minute Gurley, made in Troy, New York, or perhaps a Buff and Buff.

198. The author, who is also a licensed land surveyor, can't resist the temptation to editorialize just a little: surveyors traditionally have never charged their clients enough for their services. The surveyor is the one professional at any real estate transaction who answers the tough questions, but he is the one who makes the least money.

199. Chapman, "Who Killed Frank Teal?"

200. Most of Frank Teal's records are kept at the Egbert Benson Historical Society in Red Hook. They consist mostly of field notes, letters and work sheets. The final maps mostly were given to his clients.

201. Frank Teal probably ran a random traverse line through the woods of the subject property where he had the best line of sight. Distances between traverse stations would be measured with a steel tape (possibly a Gunther's chain when Teal began his career) and plumb bobs. He would then "reduce" his field notes at his home by using trig tables and multiplying his figures using logarithms. Now, surveyors measure distances with electric light beams, global positioning receivers and

even robotic instruments. They do their calculations on a computer, and their maps are drawn with the help of sophisticated software.

202. Chapman, "Who Killed Frank Teal?" There was actually an important reason why Teal didn't want his notes in different shades of ink. If he had to produce his notes as an exhibit at a trial, a smart lawyer could claim that he had "doctored-up" the different shade.

203. Dows, unpublished short story.

204. Ibid.

205. Chapman, "Who Killed Frank Teal?"

206. *Poughkeepsie New Yorker*, December 24, 1949.

207. Finally, sometime in the 1950s, Frank's house did burn down completely. A new home was built on a cinder block foundation a few yards closer to Stone Church Road than the old house. Frank's hand-dug well is still there though completely covered with a stone slab for safety. Employees of the Old Rhinebeck Aerodrome, the current owners, think that there is a ghost (of the female persuasion) haunting the new house.

208. *Poughkeepsie New Yorker*, December 25, 1949.

209. Ibid.

210. Chapman, "Who Killed Frank Teal?"

211. *Poughkeepsie New Yorker*, January 4, 1949.

212. Chapman, "Who Killed Frank Teal?"

213. In a December 16, 2002 *Poughkeepsie Journal* story by Rasheed Oluwa, the reporter quoted Raymond Lennon, an investigator with the state police in Rhinebeck, "Lets just say interrogation methods were 'liberal' back then."

214. Chapman, "Who Killed Frank Teal?"

The 1963 Poughkeepsie Book Burning

215. *Poughkeepsie Journal*, April 4, 1963.

216. William F. Gekle, *The Lower Reaches of the Hudson River* (Wyvern House, 1982), 68.

217. *New York Times*, May 23, 1963.

218. *New York Times*, April 27, 1963.

219. Ibid.

220. Gekle, *Lower Reaches of the Hudson River*, 69.

221. Helen Chapman, *Barrytown Explorer*, May 1963.

222. *Poughkeepsie Journal*, April 24, 1963; *Poughkeepsie Journal*, April 25, 1963.

MILESTONES

223. Richard J. Koke, *New York Historical Society Quarterly* (July 1964): 261–62. There are six milestones preserved in the collections of the New York Historical Society and the Museum of the City of New York; Richard M. Lederer Jr., "Post Roads, Turnpike Roads and Milestones," *Westchester County Historical Society Quarterly* 64, no. 1 (Winter 1988).

224. James Spratt, "Milestones of Dutchess County," *Hudson River Valley Review* (Spring 2010): 112.

225. Laws of New York, Eleventh Session, Chapter 88, March 20, 1788.

226. Koke, *New York Historical Society Quarterly* (July 1964): 264.

227. Maurice C. Ashley, *Dutchess County Historical Society Yearbook*, 1935, 18.

228. Richard J. Koke, *New York Historical Society Quarterly* (January 1958): 79.

229. Richard J. Koke, *New York Historical Society Quarterly* (July 1950): 167.

About the Authors

Tatiana Rhinevault is a graduate of the Art Department of Moscow State University. She and her husband met while working together in 1990 on a joint mapping project for the U.S., British, Canadian and Australian embassies in Moscow.

Ten-year-old Peter Rhinevault has exhibited fine art with his mother and has studied piano and violin.

Carney Rhinevault is Hyde Park town historian and is the author of *The Home Front at Roosevelt's Hometown: Small Town America During World War II*. He has researched thousands of deeds, wills, maps and other documents during a long career in surveying and cartography.

Visit us at
www.historypress.net